The Wanderings
of the Grail

Frontier Publishing

Adventures Unlimited Press

The Wanderings of the Grail

*The Cathars, the search for
the Grail and the discovery
of Egyptian relics in the French
Pyrenees*

André Douzet

Adventures Unlimited Press
Frontier Publishing

for more information, see www.perillos.com

Frontier Publishing
Postbus 10681
1001 ER Amsterdam
the Netherlands
e-mail: fp@fsf.nl
http://www.frontierpublishing.nl

printed in China

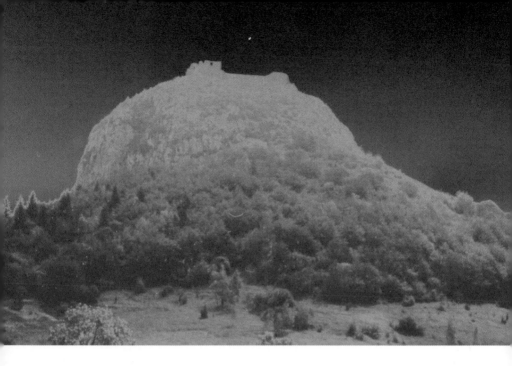

Table of Contents

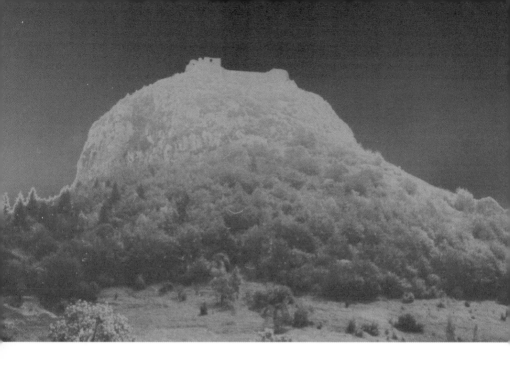

Part I

Arques and its enigmas

Chapter 1
Egyptian statues and rituals in Arques

The town of Arques has always been bigger and more important than the village of Rennes-le-Château, situated to the left of the road further west. But with the fairly recent rise to fame of the latter, all events in the former have been eclipsed and reinterpreted. All of a sudden, it seems as if the Dukes of Arques played a minor instrument whereas the lords of Rennes-le-Château played the first violin. The facts of history have been inverted.

In the history of Rennes-le-Château, Arques is best known as the location where a stone outcrop is believed to have been the backdrop to a painting of Nicolas Poussin, Les Bergers d'Arcadie (The Shepherds of Arcadia), which is believed to hold an important clue in the puzzle of the mystery. But other aspects of the history of Arques that do not clearly fit within the general framework of the "Rennes-le-Château enigma" are normally excluded from discussion.

One mysterious discovery occurred in the early years of the 20th century, at the time when the entire region had succumbed to one of the hottest and driest summers on record. Although the wild vegetation seemed to cope with the extra-ordinary weather, humans and animals suffered cruelly. The people realised that it was important to identify and trace all possible sources of water, as it was clear that a total lack of it was imminent.

In those days, the water distribution network was very basic, resulting in common shortage at the usual distribution points. The authorities were greatly worried about the state of the network in general, but the extreme drought had only added to their worries. Measures had to be taken. Initially, they decided to supply drinking water by using vehicles equipped with cisterns. However, this palliative was only of benefit to humans and did not address the needs of the animals. The solution completely disregarded any requirements the farmers had for their crops; their harvests were close to being compromised - resulting in a loss of income and food. A major economic crisis could soon envelop the region.

Faced with these critical prospects, certain landowners decided to try to reactivate old springs and fountains that had been abandoned - if not forgotten -for decades. Modern maps only mentioned contemporary sources of water, which meant that the older people had to be asked to think and remember where the old sources were. The initiative was a success and many small, forgotten water points were found, without too many difficulties. Unfortunately, the total volume of water available

from these sources was not enough to meet the needs - a contributing factor as to why they had been abandoned in the first place.

An elderly person living in a small hamlet near Arques caught the attention of all inhabitants of Arques when he remembered what he called "an underground lake". The man quickly located the place, without actually being able to find the old access path. That same day, heavy agricultural machinery was brought in, as well as teenagers from the local and surrounding communities. All through the afternoon, the men and the machines opened up the site. In all haste, they moved the heavy rocks and cleared the undergrowth. As the old access route was no longer in existence, the men pushed through a new access road, without any regard as to what might lie in their path. By evening, and totally exhausted, the workmen had been able to open up the area, which had once again become a usable water point.

The hard work had confirmed that there was indeed a cavity, located under the rock. It was a very low, narrow and muddy bowl, ending up after a few metres in a natural room, containing a significant amount of water.

In the early hours of the morning, two motor-driven pumps equipped with batteries came to the area, to transfer the invaluable liquid to cisterns, thence to be given to the local population.

A few days later, storms came in, thus re-establishing the natural hydraulic balance. Once again, the underground lake no longer served a practical purpose and was deemed to be dangerous and a serious health hazard: people might play in the area or wander into the cavity. The access was closed off once more. Slowly, the vegetation began to take root again.

This example of crisis management seems unimportant, but one of the volunteers who had participated in the endeavour passed certain information on to his son, who would remember his father's story for the rest of his life - if only because his father told it to him many times.

One aspect of the story is that two workmen from the National Forestry Commission decided that before closing the access to the underground cavity, they would explore the area - and the

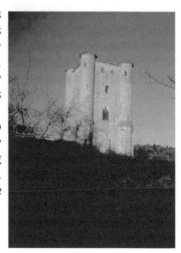

The "donjon" of the castle of Arques

4

cave in particular. They used a flat raft, which was the only possible means of exploring the low cave, which soon began to rise to a kind of projecting ledge, on which they could stand. From there, the water seemed to move slowly, then to disappear into a deep bowl, deep enough that they could not see the bottom of it. As they had no experience in speleology, the workmen decided to return to the entrance.

Another aspect is that something occurred during the time when the heavy machinery was used to remove the huge blocks of stone, as well as removing some trees that obstructed the operation. Because of the extreme pressure the workmen were under to find water, few took any notice of what the tractor devastated under its weight.

It was only the following day, during an assessment of the work that had been carried out on the day before, that one of the men, along with two of his companions, made a strange discovery. This time, they were not under any pressure and hence had the time to look around the entire site.

They noticed that some of the pieces of rock were different from others. Specifically, it seemed that some stones of a particular type had been assembled in certain accumulations. However, it was an open question as to whether these heaps of stones had any other origin than ground clearings, for example, they might have been made as preparation for the cultivation of vines, or other purpose. Furthermore, the workmen were more than just interested; somehow, they were intrigued.

What drew their attention specifically was that amongst the dispersed rocks, there were some crushed bones and shards of what was obviously very old and dark pottery. Some stones also had signs and designs, suggesting the site might have been of archaeological value. They collected what appeared to them to be in rather good state, worthy of being carried off the site and preserved for posterity.

We are unaware of the exact details of what they took with them. However, our source remembered that his father spoke to him about "circular pieces of metal that were very oxidised". Does this remark indicate that it could be metal objects (perhaps money), made out of bronze or copper? It definitely argues against the possibility that it was a "noble" metal, as that would not be subject to such a type of natural degradation. Apparently, amongst the material that they removed to safety were also some small, dark grey metal tools, some shards of pottery and some large buttons made out of bone, horn or ivory.

Our source's relative had not mentioned the name of his comrades, making it difficult for anyone to verify the story, or to track down the other witnesses. However, by chance or foresight, our source had preserved certain of the objects that had been found.

For many years, we stayed in mutual contact, having enthusiastic discussions with this now deceased person. It took fifteen years before he was willing to indicate to us the place of the old underground lake, on the condition that we would not reveal his identity. But, more importantly, he agreed to show us the objects that had been found and allowed us to photograph them.

These were a small container, some bronze parts, a bone or horn pallet, bone or horn buttons, but most notable of all, two small figurines that were very old, and dark, and, most importantly, seemed to be of Egyptian origin - or if not of Egyptian origin, definitely in Egyptian style.

With such remains on the site, what function could the place have served? Although it seems to have been forgotten over time, it seems clear that this site in the vicinity of Arques was occupied in our remote past. Its location, near an underground lake, seems to be ideally suited to a religious purpose, perhaps connected with the dead. If there had been less urgency to complete the work on the site, more pieces of the puzzle might have remained intact, and more clues to its past importance would have been discovered.

That the site's importance was lost should not come as a major surprise; the access route had been lost as well, underlining the remoteness of the area. Nevertheless, it is clear that the site was selected for several reasons. Initially, the proximity to the deep cavity and the lake seems the most logical reason why the place was chosen by our distant ancestors. That the water is hidden in a cave must have added to the possible religious significance of the location.

Caves were considered to be entrances into the Underworld. They were the entrances into "Mother Earth", access into the Womb (of Creation). The waters of this lake could thus be compared with the birthing fluids of the mother and would have given the entire complex a sacred nature. As the inspection revealed the presence of a number of bones, it seems that the site was used for burials. This should not come as a surprise. The caves were identified as a return to their origins, to the womb of the Mother - although the birth was believed to occur in the "Next World". The arrangements of the stones might suggest that they were used as part of the "tombs". Perhaps they were just simple piles, or stone heaps, although they might have been more impressive, perhaps even prehistoric stone monuments, together forming a necropolis. Throughout prehistoric times, the worship of the dead was enveloped by rituals that incorporated pottery, jewellery and other objects, often of exceptional quality and often made for purely votive use. This could explain the use of the other finds.

The morphology of the place lent itself perfectly to the installation of a sanctuary and offered all the ritual characteristics it required, specifically the presence of a cave and water - the cave considered to be a sacred "temple" since the earliest arrival of our ancestors, tens of thousands of years ago.

But there was nothing intrinsic to make the site stand out from similar ones in the region, nor in France as a whole, nor even in Western Europe. The oddity is that the site had a statuette that can be identified as an Egyptian divinity. The question arises as to what an Egyptian statue is doing in Southern France. Although in Graeco-Roman times the Egyptian cults, including those of the dead, were exported across the Mediterranean Sea and throughout the late Roman Empire, this statuette does not fit within that framework.

The statuette is that of a traditional (i.e. pre-Graeco-Roman period) Egyptian deity, Sekhmet. Sekhmet means "The Mighty One," and she was one of the most powerful of the gods and goddesses. She was the goddess who meted out divine punishment to the enemies of Egypt. She accompanied the pharaoh into battle, launching fiery arrows into the fighting ahead of him. Sekhmet could also send plagues and disease against her enemies, but was sometimes invoked to avoid plague and cure disease. It is an intriguing coincidence that she was found in a sanctuary that was identified as the cure of a plague - drought. However, Sekhmet does not have any clearly identifiable funerary aspects - unlike for example, Osiris, the Egyptian Lord of the Dead.

In essence: the discovery of a Sekhmet statue is very odd, for several reasons. But rather than try to delve into the enigma here, let us for the moment merely note it down, and leave the interpretation for later.

Several people held this object in their hands and many opinions were offered on the subject. What is beyond any doubt is the authenticity of the discovery. There are no grounds for claiming it to be a fraud or a modern reproduction. The small statuette was the subject of several exhibitions; its origin and antiquity were never placed in doubt, not even by specialists from Lyons. Except, that is, until one person's input was sought: an eminent expert from the British Museum in London.

At this point, the scenario becomes surreal. This person admitted that the statue had an obvious Egyptian source, but questioned its antiquity. According to this expert, the statue was only 300 years old! We could argue against such a dating, but it is clear that a one-line statement regarding the dating made by the expert is odd. Who in Egypt around 1600 AD would be making this statue of a deity hardly known, if at all, and definitely not popular, and how did it end up in Arques? Although the

7

enigma of its location remains whether we date it to Antiquity or 1600 AD, at least in Antiquity, there is a framework: for example, the ancient Romans might have brought it to there and incorporated it into an existing, or a new necropolis. Who would do such a thing in 1600 AD is a much bigger question.

There are some possible scenarios: an inhabitant of Arques might have been buried with this artefact, after a journey to Egypt, or it might have arrived from Egypt via some middleman. But in the past 300 years, no-one would have taken the risk of burying anyone in the middle of

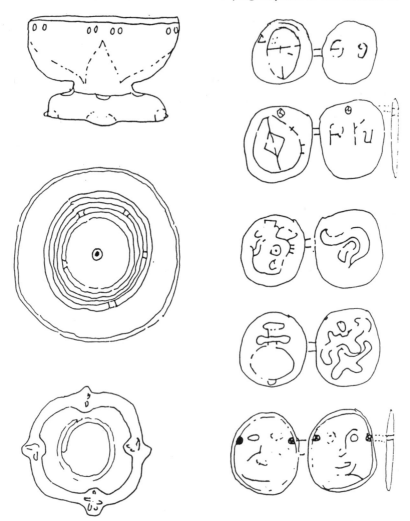

Some of the discoveries made at Arques

nowhere without informing the authorities of the location of the grave. The town hall's registers do not reveal any such events.

Again, the astonishing information from this expert is that it is classified as Egyptian in nature, but is only 300 years old. Again, the question arises as to who commissioned the artefact and why was it made in the first place. The Egyptians no longer buried their dead according to the ancient rites, and even if they did, the burial was not in Egypt, but in Arques.

Perhaps we should look for the burial of a local Freemason. Their rites were deemed to be "Egyptian" and hence they used Egyptian imagery. As Freemasons were buried with some of their regalia, this could go some way to explain the enigma, but once again not the date: such rituals are not known to have existed in 1600-1700; they postdate that period by another century. Furthermore, their Egyptian regalia were much more ostentatious than this statue of Sekhmet, who has no role in the Egyptian-inspired Freemasonic rituals.

Finally, why would someone in Egypt around 1600 AD create this artefact? Although the Egyptian antiquities are currently strictly regulated and protected, this is only a development of the last few decades. In the 19th century, no such protection was in place and tombs and other antique treasures were raided, often without anyone knowing it. This is why museums of the West often have more Egyptian artefacts on display than the Egyptian museums themselves. Anyone in Egypt wanting a statue of Sekhmet would not make one, but steal one. Yet, according to this expert, someone decided to make one, rather than be "satisfied" with an original one.

However, Egypt and France do link up, but, once again, this link occurs later: it was towards the end of 1797 when Napoleon Bonaparte launched a war in Egypt against the English interests in the area. The object could have arrived in France as part of this campaign, perhaps brought in by one of the soldiers. While this is possible, once again, the statue is classified as "recent" and it still does not explain why someone would bury someone else there in the 18th-19th century, without informing the authorities of this out-of-the-ordinary burial.

However, we do not need to speculate wildly on this possibility, as it is a known fact that no-one from Arques served in this campaign, and that no-one was buried outside the communal cemetery during this period: which makes the statement of the British Museum expert extremely bizarre. With no rational explanation left, could it be that the statue is indeed very old, as it seems to be?

It is not the only Egyptian oddity that occurred in Arques. Although the story is the reason that Arques is mentioned in the enigma of Rennes-le-Château, its Egyptian dimension is never mentioned in the story.
The "enigma of Mr Lawrence" is what started the mystery of the "Tomb of Arques", or at least an important aspect of it. "Mr. Lawrence" was the man who built a tomb on his estate which bore a remarkable similarity to the tomb depicted in a painting by Nicolas Poussin, The Shepherds of Arcadia.
The estate of Mr Lawrence, known as "Les Pontils", near Arques (when

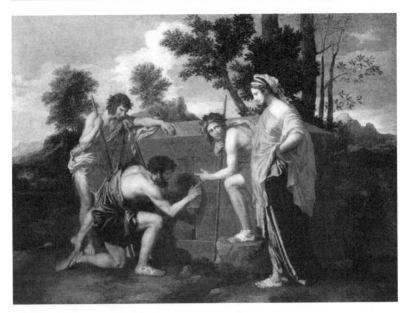

Nicolas Poussin's The Shepherds of Arcadia

coming from the direction of Rennes-le-Château), was incorporated in the books of Gérard de Sède, specifically Le Trésor Maudit, (The Accursed Treasure). De Sède was the man who brought the mystery of the small village to the attention of the French. From there, it was given to a world-wide audience by Henry Lincoln, when he chanced upon de Sède's book.

De Sède wondered whether the landscape in Poussin's painting was identical to the landscape in the background of Les Pontils, inclusive of the tomb. Although Poussin painted the picture in the 17th century and Lawrence built the tomb in the 20th century, the obvious question as to how Poussin could have painted a tomb that was not there, is not answered by either de Sède or others who have followed in his footsteps. However, resolving that problem is not our concern.

How did the mystery of the tomb begin? Louis Galibert and his family moved into Les Pontils in 1880. It was on this property that his grandson built a vault, on a headland close to the main road. The entire project was finished in 1903, at the time when Saunière - the enigmatic priest of Rennes-le-Château - was not only alive, but also resident priest of that village.

Louis's wife, Elisabeth Galibert, was be buried in this vault. However, shortly afterwards, Louis Galibert left Les Pontils for Limoux, where he

11

acquired a concession in the local cemetery. The remains of his wife were transferred on 12th December 1921.

The property was placed for sale and quickly found a buyer. Three Americans bought it and quickly moved in. Americans living in Arques before the Second World War is strange enough, but perhaps this strangeness was matched by their enigmatic characters: both Mrs. Rivarès and a man she described as her son, Mr. Lawrence, were "out of the ordinary". The third American was Mr. Lawrence's grandmother.

Madame Emily Rivarès was French, although she was born in Paterson in the United States. Her son, Louis Bertram Lawrence, was born on 25th October 1884 in Hartford, Connecticut. His father had been born in Amsterdam, in the Netherlands.

Therefore, although of European origins, settling down in Arques was not the most logical of choices to make and hence "out of the ordinary" was also the opinion of the local people... Mr. Lawrence, a man described as being older than 50 years (when in fact he was somewhat younger), was apparently a very ill man, his health demanding a completely peaceful lifestyle, something which he obviously thought the South of France could offer him.

He seldom left his house, but when he did, he often went into the factory on the property, which remained lit until dawn. Indeed, the locals were watching... Those who passed by, heard "strange words", no doubt American expletives they could not understand, but they also remembered some bizarre work that went on outside.

Mr. Lawrence's doings received even more interest when it was learned that he was well-educated, a scholar with many diplomas, some of them apparently received from the best universities and authorities. He also seemed to have a special knack for mastering intriguing measuring instruments, the complexity of which astonished the inhabitants of Arques. Regardless of what he did, or from what income on which the family lived, one day, Mr. Lawrence decided to construct the famous tomb, on top of the existing vault.

If Mr. Lawrence had never heard of Nicolas Poussin and had not seen the tomb depicted in The Shepherds of Arcadia, it is a major coincidence that his design and the tomb drawn by Poussin are so similar. It seems more likely, being a man as educated as he was, that his design for his tomb was indeed copied from the Poussin picture. After all, inspiration has to come from somewhere...

In Histoire du Trésor de Rennes-le-Château, Pierre Jarnac describes the tomb as: "This tomb, which is almost hidden by trees, was erected on the edge of a cliff, up by a little bridge that passes over the bed of a stream

(now dried up) known as 'Le Cruce'. It can be seen quite clearly from the road to Arques. It takes the form of a parallelepiped [geometric solid whose six faces are parallelograms], surmounted by a truncated pyramid."

Louis' grandmother, Marie Rivarès, died on 28th November 1922, the year after moving into Les Pontils. In accordance with her wishes, her body was embalmed and buried in the tomb. Some time later, in 1931 or 1932, Louis' mother died. Now all alone, the few people who passed the estate from nearby stated that "Monsieur" was practising strange rites, that the cries and the noises emanating from the estate during the night intensified, as well as the work, its nature never specified.

But some people in Arques seemed to know what Mr. Lawrence was doing. Lucienne Julien, confidante of Déodat Roché, the Mayor of Arques, stated that Mr. Lawrence practised an Egyptian rite of embalming the body of his mother. Once this ritual was completed, he performed the same ceremony on the two cats of the household. Knowing that her statement might seem outrageous at first, Julien offered photographic evidence of the embalmed cats - and mother - as proof of her claims. But even more odd was that Mr. Lawrence was not alone when he performed these rituals. He was not a lone eccentric as some might argue; five men and women assisted him in these rituals that belonged to a different and what should be a long forgotten time.

All of a sudden, Arques has two Egyptian oddities, both linked with funerary aspects: the old cemetery with the Sekhmet statue, and Mr. Lawrence using Egyptian funerary rituals for the burial of his family and

The location of "Poussin's tomb" at Les Pontils

13

household pets. The question is, therefore, whether the creation of the tomb fits within a careful plan as to how his family would be buried. Furthermore, where does this leave his inspiration to copy the tomb from the Poussin painting, which at first glance does not seem to have any Egyptian connotation.

However, many authors have drawn attention to the inscription on the Poussin tomb: ET IN ARCADIA EGO - And in Arcadia I (am). The question as to who is in Arcadia, is often answered by "death". It is assumed that as the shepherds point towards the tomb, "I" is interpreted as death.

Arcadia was often considered to be a metaphor for Paradise, and some argue that the message Poussin tried to impart in the painting was that death existed even in Paradise - which is contradictory to most legends which argue that in Paradise, death has no place, as those in Paradise have passed through death to come to there.

Assuming death is indeed central to the painting - which is not illogical, seeing that the tomb is the central object of the painting - then we are back in the realm of what obsessed Mr. Lawrence about Egypt: their funerary rituals - and also of the location where the Sekhmet statue was found: a necropolis.

That Mr. Lawrence was not merely indulging in what we would nowadays describe as nonsensical New Age rituals, seems supported by the knowledge that six of his "discreet visitors", who assisted him in his funerary rituals, all belonged to an organisation based in Toulouse, an organisation that was however not listed in the register of the prefecture of Toulouse. As a result, it was not an "official organisation".

The society was an independent group which was known under the name of "Carré d'Ether", the Square of the Aether. The name suggests that the society was esoteric-alchemical in nature. The group consisted of people who lived in and near Toulouse, somewhat distant from Arques (and definitely so in those days), but their reunions occurred four times per year, in the region of Chalabre (nearer to Arques). As the group was not entered in the register, there is nothing that is known about their statutes or rules, except one or two documents that Lucienne Julien was able to collect. However, these documents were not very revealing.

Unfortunately, few researchers seem to be aware of this information, even though it has been in the public domain for some time and Franck Marie is one of the few researchers to have drawn some attention to the enigmatic events surrounding the tomb of Les Pontils. However, through the interest Lucienne Julien had in Mr. Lawrence, we were able to learn certain other details about this individual.

The local authorities, although aware of the rumours about Mr. Lawrence,

never intervened, but it seems that other departments of the French administration were interested in this man... and it seems that this interest was very profound. Representatives of the police force, as well as other organisations, more discreet (i.e. dressed in civilian clothes) visitors regularly came to see Mr. Lawrence.

The events happened regularly, rather than "suddenly". There was no animosity and the encounters were always entirely peaceful. They were routine visits, almost courteous. It was the police force that would inform the municipality of Arques rather laconically that "everything was under control" and that there was absolutely no necessity to worry about what was going on at Les Pontils.

However, such over-benevolence on the part of the police towards the local authorities caused even more suspicions, resulting in wild rumours echoing around the town. The rumour mill would even argue that "Mr Lawrence" was actually Lawrence of Arabia; others believed he was a member of a foreign secret service, working on French territory... working together with the French authorities... Although there is no doubt that the locals were wrong in their conclusion, all the ingredients pointed clearly to the presence of some intrigue on the grounds of Les Pontils. And the entirely accidental possibility that the choice of the tomb design was identical to that of Poussin seems to become less and less.

After the strange rituals surrounding the death of his mother and his two cats, there were no more odd goings-on at night, no more cries or strange visits. Mr. Lawrence left his property and settled in the town of Carcassonne, where he was able to waste away his susbstantial capital. In the end, he died in miserable conditions, totally unregarded, on 25th July 1954, at the age of seventy - not bad for a man, who thirty years earlier was described as being very ill. If anything, the air of Arques seems to have done wonders for our friend...

Although Mr. Lawrence abandoned Les Pontils, the team of assistants that aided him in the funerary rituals did return, twice. During one visit, they recovered the strange measuring instruments that had baffled the locals. Other personal objects

The tomb at Les Pontils, before its demolition.

15

that belonged to this enigmatic character were also collected and, curiously, some digging work seems to have been carried out on his estate.

Several items remained in situ and were recorded later. They involved optical, topographic and astronomical instruments that were aimed at the professional market. There was a beautiful collection of ancient objects, of Eastern origin, and primarily related to the Egyptian worship of the dead.

The exact origin of these artefacts was never discovered. Why Mr. Lawrence required such specialised equipment was also never explained. Researchers have noted that the tomb at Les Pontils sits on the Paris Meridian, the zero longitude for the French until the end of the 19th century when international agreements placed the Zero Meridian at Greenwich. The question could be asked as to whether all these intriguing measuring instruments that Mr. Lawrence possessed, were used so that he could precisely locate the position of his tomb. We know that the ancient Egyptians used stellar alignments in the construction of their tombs. However, it would seem this explanation is slightly over the top, as we know that he re-used an existing vault, to which he "merely" added a tomb.

In the close vicinity of Les Pontils rises a menhir, a standing stone, known as "Pierre Dressée" (dressed stone). Identified as the oldest man-made structure in the area, it is proof that Arques had some importance for our ancient forefathers. In recent decades, research has shown that standing stones were often incorporated in certain alignments towards solar and/or stellar phenomena - the best known example being the English site of Stonehenge.

Did Mr. Lawrence try to incorporate certain alignments into his tomb at Les Pontils? Did he try to make it the centre or part of a sacred landscape? Or find out if someone before him had done the same thing? If so, we need to ask the question as to whether Mr. Lawrence somehow felt that Nicolas Poussin was part of this tradition. The question cannot be answered, but it does need to be asked. And we should add that many researchers, including Henry Lincoln, have always argued that the central aspect of the mystery of Rennes-le-Château involved a sacred landscape.

Officially, we are led to believe that Mr. Lawrence was a very ill man, arriving in Arques as he needed complete peace. But the strange visits he received suggest that Mr. Lawrence was not a man who was a pensioner. Perhaps he had specific reasons to come here, and perhaps it was only in Les Pontils that he was able to do his work. Furthermore, being an American in Arques, he was largely unable to communicate with the local people

- or rather, the local people were largely unable to communicate with him - if only because he seldom left his estate.
Were the obscure funerary rites the main reason why Mr. Lawrence came here? But how did he, an American, know the esoteric group from Toulouse? And why did they come to assist him in his bizarre rituals? Was he working for a foreign government, reporting to the French government, as the strange police visits might indicate? Perhaps he was aware of an ancient sanctuary that existed on the site, which is why he wanted to reproduce old ceremonies going back thousands of years.

If anything, this might explain the bizarre opinion of the expert of the British Museum. Just suppose that somehow there was a group of people in the area with knowledge of or a specific interest in the ancient Egyptian funerary rituals, it might explain how this group of people were aware of ancient Egypt rites, deities and statuettes, and were able to reproduce these. They might have been the ones who worshipped in or around the underground lake, where they placed the Sekhmet statue, discovered during the emergency water works. This could allow for a dating of the statue of 1600 AD.
Just supposing that this might be true, then it would mean that Arques was either important to, or was the home of, a group of individuals to whom the Egyptian religion, and specifically its funerary aspects, were extremely important. If this is the case, then certain other aspects of the history of Arques and the general region would actually make sense. Specifically, this would make sense of the illustrious career of Arques' most famous person in recent times: Déodat Roché.

Chapter 2
When Cathars meet across centuries ...

Did all the knowledge of a possible ancient sanctuary or the strange circumstances that propelled Mr. Lawrence to Arques disappear into oblivion? We have good reasons to assume that at least one person in Arques was informed of the importance of some of the geographical locations and the reasons behind the rites. The person entrusted with this knowledge was Déodat Roché.

Déodat Roché was born in Arques, on 3rd December 1877. He spent his entire early childhood in the village, a childhood which, according to those who knew him, was turbulent, if not choleric, even though he was recognised for his sharp intelligence. His parents came from local families; specifically his mother had ancestors in the region going back to the 12th century. His father was descended from a line of doctors and notaries and he himself worked as a notary. His main interest was not work, but the many religious currents that had and continued to sweep the region and history in general. He had once planned to enter the priesthood himself to pursue this interest. Although he did not follow up on this idea, he did study religion and devoted himself to aiding his fellow citizens in a return to a proper form of worship.

Déodat grew up in this environment, but as an adolescent, he left his native village for the college in Carcassonne. He then transferred to the University of Toulouse, where he completed two strands of education, one being Law, the other being Philosophy. With these credentials to his name, Roché approached the magistrature and carved out a career in Limoux and Carcassonne, before becoming the President of the Courts in Castelnaudary and Béziers. However, he categorically refused to sit on the bench, as his convictions prohibited him from pronouncing a death sentence on any human being. In 1943, during World War II, the Vichy Government removed him from office, officially retiring him from his duties. The specific reasons were that it "had to do with his history of religion and spiritism".

Roché then became mayor of Arques and managed the interests of the village with such conviction that in an incredible display of support, he acquired an absolute majority of the votes at each election. From 1945, he was also elected to the Regional Council's General Assembly. He made some important interventions as regards the economic interests of the Haut-Corbières, so much so that even members of the opposition voted in favour of his proposals.

It was his personal interest in religion which caused Roché to become intrigued by these enigmatic locations in his town, but there was another spot that also fascinated him. Today, this place is known to the inhabitants of Arques under the name of "the oratory". Déodat Roché had a close affinity with the site, which was, furthermore, not too far from the previously mentioned necropolis. He cared for the location so much that he walked there every morning - as if it was a morning ritual - and had an apiary installed there.

Although it is known as an oratory, oddly enough it is not listed as an official religious site. Rather, it is a site of local curiosity. The location is becoming better and better known, especially as it crosses a botanical route. But there are too few written documents available that justify the presence of a pilgrimage, a procession and dedicated worship at this curious religious site.

The site itself is an artificial cave, in the shape of a dome, open to the north, and closed by a high grid. Inside, there is a large statue of The Virgin, as well as some memorial plaques. Even today, it is well-visited by devotees, as can be witnessed by the regular replacement of fresh

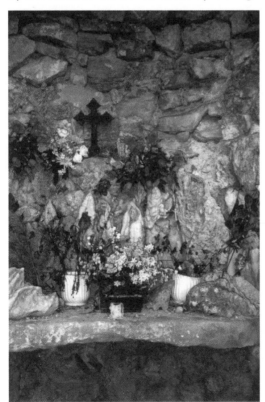

flowers. Let us note that the form of the construction is that of a half-dome, and that the stones set curiously on the top of the cupola create the image of the head of a bear, with its mouth open.

The oratory might have some links with the mystery of Rennes-le-Château. The large fresco decorating a wall of the church of this village (to the left when entering) incorporates a dome that is identical to that of the oratory of Arques. This may be coincidence, or or it may be intentional.

The Oratory of Arques

There is also the mysterious inscription on the tombstone of the Lady of Hautpoul: REDDIS REGIS CELLIS ARCIS. A lot has been made of this inscription and with trepidation we add some more.

Reddis could be the old name for Rennes-le-Château. Alternatively, it could be derived from the Latin verb "reddo", "to return". Regis translates straightforwardly as "king", with "rego" having the specific meaning of "to govern", "to direct". Translating Cellis is tricky, as "cella" could mean "cabin" or "niche", a shelter. However, the word Cella also exists in France and indicates a sanctuary or an oratory. Finally, Arcis could come from the verb "arceo", "to contain" or "to lock up". However, Arcis is also close to Arques. In essence, the inscription could be read as "To Rennes the king, to Arques the sanctuary". And, of course, we note that Arques has its fair share of enigmatic sanctuaries.

So what sanctuary? The rhyme of the inscription is obviously a repetition of four times IS. With some imagination, we could state ISIS ISIS, the name of the Egyptian goddess - a goddess closely associated with Mary Magdalene, the patron saint of Bérenger Saunière's church - and by extension the central theme in all of his building works in Rennes-le-Château. Still in the purely theoretical assumption that this is correct, we would have another hint to an Egyptian goddess, in fact one of the most famous ones. She was closely associated with the cult of her husband and brother, Osiris, the Lord of the Dead. In fact, in Graeco-Roman times, the cult of Osiris became more and more unpopular. Osiris was considered to be the God of the Dead, but the Greeks and the Romans wanted to celebrate life, and hence ended up having a closer affinity with his wife, Isis, resulting in a massive popularity and sanctuaries to Isis and her Mysteries across Europe.

Another possible link between Rennes-le-Château and Arques comes from British author David Wood. He measured the distance between the respective churches of Rennes-le-Château and Arques and noted that the connecting line was divided at a third of its length by the French Zero Meridian. Again, is this a coincidence, or is it intentional? And we can only wonder whether such aspects of the mystery only intrigued modern researchers like Wood, or whether Lawrence or Saunière might have equally been intrigued by such geometry - which could explain the measuring instruments in Lawrence's possession. It would also bring Arques more firmly into the stronghold of the mystery of Rennes-le-Château.

However, such interpretations are dangerous and should be taken with the necessary dosage of salt. What is factual is that the oratory is dedicated to Mary, and that its origins are very old - possibly dating back to the time of the crusades. The interior is decorated with limestone, to give the impression of a cave.

It is not the only Mary that is important in our quest. During work carried out in Arques, workmen stumbled upon a cavity in which they found a Black Madonna, whose cult is definitely linked to Mary, though it is unclear whether she was linked with the Virgin Mary or Mary Magdalene, and if the latter, whether by extension to Isis.

Could these ingredients warrant the assumption that Isis was indeed worshipped in this location? Did Déodat Roché know this and did he take part in or maintain some of the rituals that were involved in this worship? According to Lucienne Julien, a woman who was Déodat Roché's closest confidante for many years, the answer is a definite yes.

This should not come as a major surprise to anyone who has ever heard of Roché. Roché felt that his most important task was to carry the true message of Catharism, which he considered to be a resurgence of Manicheism, to a larger audience.

Manicheism is the belief in two opposite and independent principles: the Good and the Evil or God and the Devil. The belief was preached by Mani, who was born in 240 AD, although the concept of opposite deities is now known to be much older. Although this prophet was put to death by Bahram 1st in 277AD, his doctrine was most intriguing: "Souls are prisoners of darkness, and they must fight to recover their original destiny, abandoning the body that imprisons them."

Mani was visited twice by an angel, "the Messenger of the light of Paradise", who asked him to proclaim his doctrine far and wide. After a pilgrimage to India, he came back to preach in Iran, where the Zoroastrian Magi of the court imprisoned him. These travels in themselves were no mean feat for a man who is believed to have been lame in one leg.

Although the doctrine of opposing deities is often referred to as Manicheism, implying it originated with him, this, as mentioned above, is now known to be no longer the case. So where did Mani get his knowledge from? One story argues that he received it after his adopted mother gave him four books of sacred knowledge on her deathbed. The knowledge was said to have been collected in Egypt at the time of the Apostles by a certain Scythianus, a merchant who lived on the Palestine border and who had learned the "wisdom of the Egyptians". "Scythianus" sounds as though he was in fact a man from Scythia.

This would suggest that in origin, Manicheism was an Egyptian belief, and possibly identical with the belief of the ancient Egyptians. If the entire story is true, then it would suggest that the visions that Mani had were not chance events, but perhaps that he had carefully studied or learned how to experience the divine directly.

21

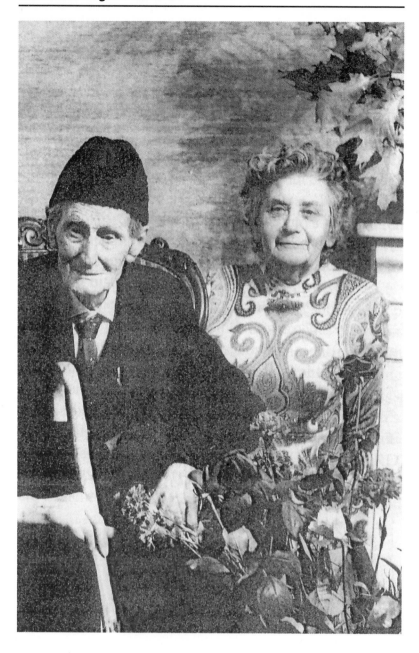

Déodat Roché and Julienne Lucien

Roché's main interest was Catharism and he felt that the abandonment of "evil" - the physical world of the body - could be identified as the central aim of Catharism, derived from the Greek kataros, meaning "pure". Their doctrine argued that the devil was a servant of God who rebelled, and that souls are neither good nor evil. The material world was evil, as it had been created by the Fallen Angel, who tried to trick the souls of men, who belonged by nature to the Kingdom of Heaven, into denying their divine origin, in order to experience life on Earth.

The dualist nature of the Cathar religion has been gleaned from the works of certain inquisitors, particularly Anselm of Alessandria and Rainerius Sacchoni. This Cathar duality is currently accepted by many scholars on the subject, including Yuri Stoyanov, whose book, "The Other God", argues the case that large sections of the medieval world, including the Cathars, have always believed in an opposite God, balancing the "Christian God" as it were. It was felt that God ruled Heaven, the Devil ruled Earth.

The role of Roché in identifying this duality, as well as bringing it to the world, cannot be overestimated. At the same time, his role has been forgotten. At the time of writing, a websearch on the words "Catharism - Manicheism" resulted in 84 pages found. Add the word Roché to the search, and none are retrieved. Some of this absence is due to Roché himself. He was a man who tried to stay as far away as possible from fame, pride or controversy. He tried to live in accordance with his beliefs, as well as according to the principles of what his research uncovered.

Still, Yuri Stoyanov and other experts on the subject, such as Tobias Churton, all now argue for an influence of Manicheism on Catharism, and even speculate about the possibility of a direct influence: "During the early twelfth century, Bogomil missionaries began the journey up the Danube to the west, possibly as a result of the persecution of Bogomils in Constantinople. What remains a mystery is whether these Bulgarian missionaries were, in fact, the direct founders of Catharism in the Languedoc."

Stoyanov et al. are a generation - if not more - removed from Roché. One of the people Roché directly inspired was Simone Weil, a French philosopher of the inter-war period. Roché's discussion on the Cathars' rejection of the Old Testament Jehovah particularly appealed to her. Living during some of the darkest days of Europe's history (she died of tuberculosis in 1943), Weil saw the Roman Empire and its child, the Catholic Church, as the original source of European totalitarianism, brutally exercised by the Office of the Inquisition - the organisation responsible for the final demise of the Cathar religion.

Roché's interest in Catharism can be traced back to 1899, when newspaper

accounts link him with the story of a tree that suddenly reflourished, which had been predicted in an old Cathar legend of Montségur. In 1922, he met the founder of anthroposophy, Rudolf Steiner, in Dornach, Switzerland. It seems that it was as a result of this encounter that he developed the idea that Catharism descended from Manicheism.

Initially, these interests resulted in Roché joining a group known as the "Etudes Esotériques" in Paris, of which Sédir was the director. Later, he attended meetings of the Martinist Order, where he discovered the contemporary influence and presence of Manicheism, largely due to the works of Louis-Claude de Saint Martin, after whom the order was named. Finally, he became a member of the Grand Orient of France, in which he climbed to the highest degrees of his Lodge in Carcassonne.

But it is equally clear that underlying this interest were the interests of his father, who was interested in the various religions, from the mysteries of Egypt, to the Persian religions and the worship of Mithras. He continued his personal researches by reading the work of various esoteric authors, such as Fabre d'Olivet, Eliphas Lévi and the works of Eduard Shuré. The works of Alan Kardec and Leon Denis also helped him in carving out his future legacy.

Between 1943 and 1978, the discovery of the Dead Sea Scrolls, the Nag Hammadi Library and the doctrine of Origen consolidated the thinking of what Manicheism had specifically represented. They would add proof to the opinions first aired in 1929, when Roché produced a work in which he tackled the relationship between the Roman Church and the Albigensian Crusades. This work stressed the importance of Catharism in history (at the time often neglected by historians), and exposed how the core of Catharist thinking would always lead to extreme fanaticism in opposition towards Catharism.

But most importantly, Roché felt that Catharism was an important link in the mystery traditions, dating back to Classical times, specifically the Egyptian Mysteries, and the contemporary initiatory organisations, of which Freemasonry is the best known example. This "missing link" between the Egyptian mystery traditions and Freemasonry should not be interpreted as a straightforward passing on of knowledge, as many authors try to allege. For Roché, it was the idea that the knowledge of the ancients had not been lost, but had been transmitted across the various generations, often in secret, and often in strong opposition to the worldy powers.

Between 1948 and 1950, Roché dedicated his resources to the composition and publication of the first series of "Cathar studies", which quickly resulted in a renewed interest in Catharism, an interest which

continues to rise to this very day. The series has an impressive list of contributors: René Nelli, Fernand Niel, Jean Duvernoy, Michel Roquebert; Simone Hannedouche, Nita de Pierrefeu, Doctor Sandkünhler, Paul Ladame and so many others... The names underline the importance of what Roché had set into motion.

It was on this foundation that Roché created an organisation in 1950, which, for a period of almost thirty years, brought together all the principal researchers into the subjects of Zoroastrism, Gnosticism, and of course Catharism. The organisation held conferences, studies and excursions in the field, as well as "summer camps", normally held in the Arques region or the surrounding Cathar landscape.

Déodat Roché died on 12th January 1978, having just turned 101. It was thanks to him that a stele was erected at the foot of the Castle of Montségur, the site of the last Cathar stronghold during the Albigensian Crusade against them, in the 14th century. The memorial was inaugurated on 12th May 1961.

However, Roché was not solely responsible for a revival in Cathar studies - although his approach was without any doubt the most academic. Today, another man, Antonin Gadal, is much better remembered for his interest in Catharism.

Antonin Gadal was born in Tarascon-sur-Ariège in 1877, in the heartland of Cathar oppression that ravaged Southwestern Europe in the 13th century. A serious injury sustained during the First World War meant that he could no longer pursue his career as a teacher. It offered him the opportunity to dedicate himself to his other passion, president of the Tourist Agency of Ussat-les-Bains. The role also identified him as the curator of the Lombrives cave, as well as several smaller caves in the area.

Gadal interpreted the Cathar religion through the landscape of the Ariège. He argued that the acceptance of the consolamentum (the Cathar act of initiation) did not only make one a "perfect" (a Cathar priest), but that it also involved a spiritual voyage, which had been mapped as a terrestrial voyage, through the cave system of Ussat and Ornolac. The initiation, he argued, ended in the Bethléem cave in Ornolac, where the "believer" was made "perfect". During the ceremony, the novice would be placed inside the impressive pentagram, carved into the wall of the cave.

The "credentes" or believers numbered literally in their tens of thousands and formed the religious flock ministered to by the perfects. Credentes generally lived ordinary lives, whereas Perfects had a strict regime of no meat, no partner or sexual intercourse (in short, no enjoyment of the material world). The credentes in general went through little or no self-

denial - though of course with tens of thousands of followers, the average of the group was not the overall norm. The main aim in life of the believer was to realise that their soul was immortal, that they could escape the cycle of incarnations, and that for this, they hoped to acquire the assistance of a Perfect, who could perform the consolamentum at the time of death.

Gadal's interpretation of the landscape was very personal. There are no historical documents that argue that the caves were part of such an initiatory network. Although there is little doubt that the caves of the region were important cultural and historical, if not religious sanctuaries at one time, there are serious questions posed as to whether this occurred in Cathar times also. Still, it is known that in the testimonies extracted by the Inquisition, the caves were described as meeting places. Of course, it could be argued that this "meeting" was of a religious nature.

What is definitely true is that Gadal's vision has attracted many tourists - perhaps this was his sole purpose, as he was the president of the tourist agency. The evidence suggests that at some level, this was the case. The Bethléem's cave was originally named "grotte de l'Hort", but was more impressively renamed by Gadal himself. We will return to this topic shortly. Remaining with the man's character, it is clear that Gadal's fame as the Cathar expert was helped because of his association with visiting Nazi scientists, specifically Otto Rahn, who came to Gadal's region of the

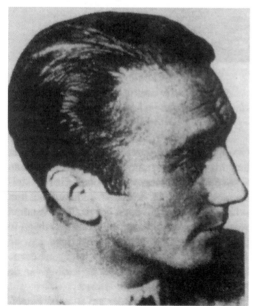

Pyrenees, in search of the "secret" of the Cathars, which was interpreted as being the "Holy Grail" - whatever that might actually mean.

Otto Rahn was born on 18th February 1904, in Michelstadt, Southern Germany. Rahn's and Roché's life have many parallels. He developed a fascination with the history of the medieval Cathars as a student.

Otto Rahn

From 1922 to 1926, he studied Jurisprudence, German philosophy and history. Rahn intended to write a dissertation on Guyot, the Provençal Troubadour on whose lost Grail poem Wolfram von Eschenbach claimed to have based his Parzival, one of the most famous Grail accounts. From 1928 to 1932, Rahn travelled widely in France, Spain, Italy and Switzerland. In the early summer of 1929, he made his first appearance in the Languedoc and settled in the village of Lavelanet. Over the next three months, he systematically explored Montségur, as well as the surrounding mountain grottoes. It was these caves that fascinated Gadal and which would bring the men into a close alliance.

Rahn described the Lombrives caverns, known as "the Cathedral" by the local people and important in the "initiatory route" of Gadal, as follows: "In time out of mind, in an epoch whose remoteness has barely been touched by modern historical science, it was used as a temple consecrated to the Iberian God Illhomber, God of the Sun. Between two monoliths, one which had crumbled, the steep path leads into the giant vestibule of the cathedral of Lombrives. Between the stalagmites of white limestone, between walls of a deep brown colour and the brilliant rock crystal, the path leads down into the bowels of the mountain. A hall 260 feet in height served as a cathedral for the heretics." Rahn tells how, "Deeply stirred, I walked through the crystal halls and marble crypts. My hands put aside the bones of fallen pure ones and knights...", echoing the initiatory path that Gadal had explained to him.

Nazis were, in general, very open to local folklore and often interpreted its symbolism very personally. Rahn was no exception. An old Languedoc shepherd's tale recorded by Otto Rahn and incorporated into his first book, displays profound mystical symbolism: "During the time when the walls of Montségur were still standing, the Cathars kept the Holy Grail there. Montségur was in danger. The armies of Lucifer had besieged it. They wanted the Grail, to restore it to their Prince's diadem from which it had fallen during the fall of his angels. Then, at the most critical moment, there came down from heaven a white dove, which, with its beak, split Tabor [Montségur] in two. Esclarmonde, who was keeper of the Grail, threw the sacred jewel into the depths of the mountain. The mountain closed up again, and in this manner was the Grail saved. When the devils entered the fortress, they were too late. Enraged, they put all of the Pures to death by fire, not far from the rock on which the castle stands in the Field of the Stake. All of the Pures perished on the pyre except Esclarmonde de Foix. When she knew the Grail to be safe, she climbed to the summit of Mount Tabor, changed into a white dove and flew off toward the mountains of Asia."

The story is a mixture of fact and legend, the armies of Lucifer being the

troops of the king of France and the Papal Inquisition. It incorporates the safeguard of Montségur as the last Cathar stance, holding the Grail (here identified as the diadem fallen from the crown of Lucifer), somehow safeguarded by Esclarmonde de Foix, a female perfect, who, according to Rahn, had survived the fall of the castle. This mixture of fact and legend was exactly the mixture that Nazi Germany required for its disillusioned people.

After 1933, Rahn lived in Berlin, where his quest for a secret primordial religious tradition - the Religion of Light - came to the attention of Nazi SS leader Heinrich Himmler, who sought Rahn's collaboration in SS-sponsored research. After first joining the SS heritage bureau, the Ahnenerbe, as a civilian, his talents were soon recognised by his superiors. Pursuaded to join the SS formally in 1936, within a matter of weeks, Otto Rahn was promoted to SS-Unterscharfuhrer.

By September 1935, Rahn was writing excitedly to the chief of the Ahnenerbe about the places he visited in his hunt for Grail traditions in Germany, requesting complete confidence in the matter with the exception of Himmler. Rahn is even rumoured to have founded a neo-Catharist circle within the SS. In the summer of 1936 he undertook, by order of the SS, an expedition to Iceland. Highlights of this journey formed part of some chapters in his second book "Lucifer's Courtiers", published in 1937.

However, in 1937, Rahn fell into disgrace with the Nazi hierarchy and was assigned a tour of duty at the SS Dachau concentration camp. In the winter of 1938-39, he wrote to the SS Reichsfuhrer requesting immediate dismissal from the SS. Rahn claimed that he had been betrayed and that his life was in danger. In a letter to a friend he openly expressed his concern about the Third Reich: "I have much sorrow in my country. Fourteen days ago I was in Munich. Two days later I preferred to go into my mountains. Impossible for a tolerant, liberal man like me to live in the nation that my native country has become."

A few months later, he was dead. On 13th March 1939, Otto Rahn died in the snow covered Tyrolean mountains. Some argue that he might have committed suicide, a death frowned upon by Catholics as the ultimate sin - but for the Cathars merely a release from the realm of the devil. Their doctrine allowed suicide but demanded that one did not put an end to one's life because of disgust, fear or pain, but in a perfect dissolution from matter.

After the War, some people wondered about the circumstances of Rahn's death. Some did indeed label it a suicide, others thought it was genuinely an accident, others that it was a murder masquerading as a suicide...

*The monument
of Antonin
Gadal*

Certain authors
would even claim
that Rahn did not die
at all, that his death
was faked, and that
he survived, living
under an assumed
identity...
Roché, Gadal and
Rahn form the
triumvirate of early 20th century pioneers that set the interest in the
Cathars on its path to fame. Gadal was in regular correspondence with
Roché. Their letters were frequently accompanied by meetings,
exchanging their points of view on the important questions as to what
Catharism had specifically stood for.

But although Gadal's association with Rahn is world-famous, the subject
of many books and quoted in hundreds more, it is largely unknown that
Roché himself corresponded with Otto Rahn, met the German scientist
on several occasions, and considered that in him he had found "an
enthusiastic researcher into the Graal, who was furthermore endowed
with knowledge and discernment on the subject of the Cathars". Gadal,
Roché and Rahn would often walk around the Ariège, trying to locate
those places which had been important to the Cathars.

Déodat Roché outlived all of them. His funeral on 13th January 1978
seems to have been thoroughly orchestrated to reflect his ideas and
philosophy. The ceremony was underpinned by Freemasonic rituals,
specifically directed towards creating a spiritual rebirth at the time of the
separation of body and spirit.

Roché knew an enormous amount about the history of his country and
region. He always made sure he had accurately preserved all elements
which he had been able to obtain, locate or discover. He would often
entrust parts of this knowledge to us, honouring us with his confidence
and knowledge. His confidante, Lucienne Julien, would also impart her
knowledge and trust to us.

Even amongst experts, one question has never been posed: was there a
connection between Tarascon and Arques? Did Roché perhaps have a
specific requirement necessitating contact with the likes of Gadal & Rahn?

After all, Arques does not seem to feature at all in the history of Catharism in the Languedoc. Nothing could be further from the truth however.

Most authors and by extension most people assume that the fall of Montségur was the end of the Cathar religion. The crushing defeat of the mountain stronghold would seem to suggest that if that castle fell, surely everything else would have fallen before. Nothing could be further from the truth. In recent years, some research has gone into the "last Cathars", specifically "The Yellow Cross" by René Weis. Weis researched the Cathar religion as it was found in the village of Montaillou, near Montségur, between 1290 and 1329, but soon realised that this pocket of Cathar worship fifty years after the fall of Montségur was not an isolated community.

The leaders of the revival were a wealthy family, the Authié, but they received the support of the local leaders, in particular the Clergue. To quote René Weis: "They sat, spiderlike, at the centre of the resistance network against the Church during the years from 1290 to 1320, and they were fabulously wealthy. That they played a decisive part in the recrudescence of Catharism has long been known." In August 1309, the famous Inquisitor Bernard Gui declared that Pierre Authié was the Catholic's Church Most Wanted Heretic.

In the aftermath of the Fall of Montségur, the Authié had gone to Italy, to become consecrated as Perfects. The Fall of Montségur had not deterred the local people from preferring Catharism to Catholicism, but the papal

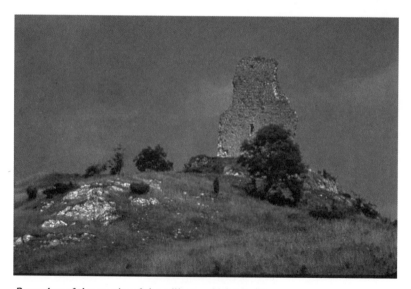

Remains of the castle of the village of Montaillou

campaign had decimated if not obliterated the presence of perfects in the region - the very reason why the Authié had to seek the consolamentum in Italy. Their Cathar allegiance was not new. In the 1230s, there were already Authiés who were Perfects, in Axe. At the time, there were several hundred Perfects in the region; around 1300, only three are known to have been preaching in the Languedoc.
The absence of priests meant that credentes had no-one to turn to in their hour of death - and need. This often resulted in an "endura", a fastening to death, after the credentes had been given the consolamentum - even though the recipient might not necessarily be close to death at the time the ritual was administered. In short, the endura was a form of Cathar suicide, a direct result of the general absence of available Perfects.

The two leaders of the family were Pierre and Guillaume Authié, and their brother-in-law Guillaume de Rodes, a minor noble, the elder of Tarascon, who had married their sister Raymonde. In the early 1290s, they had come to the rescue of Roger Bernard III, Count of Foix, in the course of the territorial disputes that had turned him into a vassal of France. Roger-Bernard III would later be consoled by Pierre Authié in March 1302, on his death-bed in Tarascon castle. It underlined the fact that despite the demise of Montségur, the allegiance of the local nobles to Catharism had not ceased.

It is within this framework that the link between Tarascon and Arques is unveiled. Around 1300, the link between Arques and Montaillou was very strong. Two of the most loyal Cathar families of Arques, the Peyres and the Maulens, used summer pastures in Montaillou. Literally, these "Cathar farmers" moved seasonally between the heartland of the Cathars and Arques. We can only wonder whether it is therefore a coincidence that so many centuries later, Roché also moved between his town and the Cathar heartland in his efforts to explain the Cathar enigma.
Another family with strong Cathar convictions were Raymond and Sybille Peyre, who moved from Sinsat, in the Ariège, near Larnat, to Arques. This move meant that Cathar sympathisers were living in Arques at the turn of the 14th century. There, their prosperous estate later provided a haven for Perfects and their sympathisers. These and other families also required the occasional presence of a Perfect, and so we find that in April 1304, some Cathar Perfects went to Arques, where a consolation was required.

The texts of four major "Arques sermons" have been preserved and are identified as being important documents that explain the Cathar doctrine. They are prime evidence underlining the dualist-Manicheic preachings.

31

As they are known as the "Arques sermons", they should also have been of obvious interest to Roché, as these sermons were literally the preachings of the Perfects while they stayed in Arques, some of the sermons being delivered in the cellars of faithful followers.

As already explained, the central theory of dualism is the belief in a God of Good and a God of Evil. It was the God of Evil (Lucifer or Satan) who had created the material world. He had fashioned the bodies, but had been unable to create the soul, for which he sought and gained the co-operation of the God of Good. This meant that our soul was destined to reincarnate again and again in the realm of the devil, unless it attained the divine knowledge of human duality, and the path towards salvation, and readmittance into the Kingdom of Heaven. This duality and message of salvation is what the Cathar perfects preached.

Pierre Authié, the perfect, argued that the devil sneaked into paradise after waiting 1000 years at its door. The sermon is very similar to the text of the Apocalypse, chapter 20, verse 3, which is a possible candidate for the last words that Saunière said before he died and which might have instilled the fear of God in the priest who had to administer Saunière's last rites.

Once inside Paradise, the devil convinced the souls that if they followed him into the world, he would give them material wealth. Many souls were seduced by this offer and fell from a hole in paradise for nine days. When God realised how depleted heaven had become, he rose from his throne and put his foot on the hole. Although he understood what had happened, he was willing to forgive the souls, suggesting that redemption would be possible. The souls on Earth were now saddened by their loss, but the devil offered them a physical body, so that they could forget their divine origin and would not miss their loss. However, as the devil could not breathe life into the bodies, he asked God for his co-operation, to which God agreed - hence the duality of the soul and the body, the divine spark inside Mankind.

The sermons state categorically that a series of incarnations awaits the soul, until it understands and has been "forgiven" for its sins. It suggests that the realisation of what truly happened, and dying in the presence of a Cathar priest, was sufficient to erase the "wrongs" of the soul.

The Cathars believed that dying in the presence of a Perfect who performed the consolamentum on the dying person would end the cycle of incarnations of the soul. However, one aspect of the Cathar rite is seldom discussed: that such a ritual would fall in the category of magical spells: that the incantation had the desired result. As regards the two eminent citizens of Arques, two questions can be posed: did Lawrence and Roché know these rites? And did Lawrence perform them on his family?

Whether or not they did, this belief needs some further explanation. In general, whether or not a soul should go to heaven largely depends on the question as to whether or not that person lived a good life. However, there is substantial evidence that shows that the ancient Egyptians believed that it was not a question of whether someone had lived "a good life" or "a bad one" (although this was important in itself). They believed it was a question of knowing what to do when one died: it was not a question of morals, but a question of knowledge. The latter makes the death ritual a magical spell, in which the spell itself guarantees the positive outcome, rather than whether or not the subject lived a good life. The Cathar consolamentum seems to fall within that same category - at least if we go on the available evidence and the conviction of the Perfects who performed it.

These teachings were made at Arques, but can also be found in the Liber Secretum, where Satan is indeed said to have been deprived of the light of his glory, and his face became human.
Still, the Cathars knew that their audience was largely Christian, and that somehow, they had to explain Jesus Christ. As such, they stated that if Jesus was truly the Son of God, he would never have had a physical body, nor could he have died on the cross, or could he have been in pain - pain being something of the physical world.
The Liber Secretum goes into great detail about the mission of Jesus. It stated that God sent his Angel Mary, so that Christ could be received by her through the Holy Spirit. However, Satan sent his angel, the prophet Elijah, now in the incarnation of John the Baptist, who baptised with water, rather than through the Holy Spirit and with Fire - the Cathar and divine tradition. The Cathars were tremendously upset by the idea that people had rejected Christ's type of baptism and hence the world continued to suffer, as it was subjected to a baptism by water - the baptism of the evil John the Baptist.
The Cathars also allied themselves strongly with the Virgin Mary, the angel of God. The Perfects bore the same title as her, Theotokos, i.e. God Bearer, as they were seen as the receptacle of the Holy Spirit and the bearers of the Word of God, in the same way that Mary had given birth to the word of God, i.e. Jesus.
The Cathars were equally interested in the "divine wife of the God of Light". This teaching was described as "the Great Secret". The story goes that Lucifer went into heaven and discovered the "Divine Wife" without her husband. Despite her initial resistance, she finally yielded to him when he promised her that she would bear his son, whom Lucifer would make a god of his kingdom, and who would be worshipped as a god. Still, the specific teachings varied greatly and in some versions, it is God

33

who descended into the Material World to mate with Lucifer's wife. The latter's interpretation seems to have been favoured by the Cathars of the Languedoc, who also believed that Mary Magdalene had been the wife of Jesus Christ.

This teaching on the role of Mary Magdalene has been described as typically "Languedoc", as there is no such role for the saint in the Bogomil doctrines. It brings us back to the speculation that has taken hold of many authors, which is whether the secret of Saunière had anything to do with the role of Mary Magdalene, specifically whether she was the wife of Jesus, and the bearer of his children... At the same time, with the interest of the Cathars in "Mary", whether Virgin or Magdalene, we need to ask whether the excursions of Roché to an oratory dedicated to Mary, was indeed part of a Cathar ritual, which he practised personally.

There are more intriguing parallels between Arques in 1304 and the 20th century: René Weis suspects that de Voisin family, at the heart of the Rennes-le-Château controversy, at the turn of the 14th century personified by Gilet de Voisins, was sympathetic to the Cathar cause. His bailiff is known to have been a Cathar follower.

De Voisins represented the ruling elite of Arques back then; Roché represented it in the 20th century. Like de Voisins, Roché was a symbol of the law and local politics. But it seems that both will be best remembered for their interest in, if not allegiance to the Cathar cause.

600 years between Pierre Authié and Déodat Roché certainly seems a very long time. But in his research, Weis was often quite astonished to discover that at the time when he made his enquiries, very little had changed in the previous 700 years. Families he saw in records from the 13th century as living in a Cathar village, often still lived in the same village 700 years later - often occupying the same plots of lands. Should we therefore rule out the possibility that certain rituals were performed and practiced and thus survived to the time of Roché? Roché was a very driven man, especially in making sure the world would come to know the core of the Cathar religion. And unlike Gadal, his claims have proved to be absolutely true. Is that proof of his brilliant methods of investigation, or evidence that he "knew" and decided to show to the world that what he "knew"?

Part 2

Montsegur

Chapter 3
The Albigensian Crusade

Montségur is an impressive sight. Standing in the car park, looking up, you wonder whether even Olympic athletes will make it to the top. Access to the car park is obviously by car, but climbing from the plains of the Languedoc, in ancient days, that trip itself must have been a long and arduous trek. Even at the end of August, the mountain peaks surrounding Montségur still reveal patches of snow, bringing home the message of what winter must be like here.

Its stunning setting has made Montségur the icon of the Cathar crusade, the Church's only Crusade organised against its own people. But then we need to remember quickly that the Cathars were not Catholics. If anything, they were more heretical than the Moors who had taken possession of Jerusalem and who had been expelled several decades previously. For a religion based on dualism, the opposition between Roma (Rome and the power of the Catholic Church) and Amor (Roma spelt backwards and meaning love) symbolised their position.

The Cathars believed that if Jesus had been the Son of God, he could not have had a material body, as nothing divine could materialise in this realm. At best, Jesus could have manifested himself as a type of hologram. However, this also implied that he could not die - and hence that he did not die on the cross for the sins of Mankind. It is clear that this left the Catholic Church in a perilous position, as their entire doctrine was based on the notion that Christ had died on the cross for Mankind.

Who was right? In one of the books discovered at Nag Hammadi, which forms part of the doctrine that the Catholic Church stamped out in the 4th century, there is The Second Treatise of the Great Seth, in which Jesus says: "I did not succumb to them as they had planned... Those who were there punished me, and I did not die in reality but in appearance..."

For a very long time, Western Europeans have looked at conflicts within their own and with other societies and nations as a battle between the various interpretations of Jesus. Though true in essence, this is also something of a garbled message. Islam, for example, is not anti-Jesus; it lists Jesus as one of its great prophets, but argues that Mohammed was a more recent "edition" of God's divine message for Mankind - a revised edition, so to speak.

The same applies to the Cathars: they were not anti-Jesus; if anything, they used the image of Jesus to illustrate their teachings. Hans Soderberg is one of several authorities who now accept that the Cathars did indeed

only give a "Christian clothing" to a more ancient, if not universal belief in the confrontation of Good and Evil and the nature of the soul caught between both.

Still, it was not the doctrine that made the Catholics anxious. It was not even the popularity of the doctrine. The real problem was that Catharism succeeded in attracting the support, sometimes overtly, of many noble families, specifically in south-western France.

The Counts of Toulouse and Foix are the most celebrated examples of these, and it was in their counties that the Cathars settled down - and build their strongholds. No surprise perhaps that Raymond VI, Count of Toulouse (1194-1222) was said to have travelled with a Cathar Perfect. In 1204, Raymond-Roger, Count of Foix (1188-1223), saw his widowed sister Esclarmonde become a Cathar perfect. In 1206, his own wife, mother of six children, was received as a Perfect - thus abandoning all worldy desires.

Other noble families, such as the Trencavels, were equally pro-Cathar. Raymond-Roger Trencavel, who ruled from 1194-1209, was tutored by Bertrand de Saissac, a Cathar scholar. It should therefore come as no surprise that that 30 percent of all Cathar Perfecti are believed to have been of noble birth. But perhaps surprisingly, it is known that many Cathar Perfecti were women - some arguing the percentage was 60 male, 40 female - even though in general, the wandering lifestyle of the Perfects was not well-suited for women.

This was the dangerous situation that the Church perceived itself to be facing. The bond between Church and state had been the backbone of the success of Catholicism. Without such an alliance, it was bound to fail; and the Church believed that the Cathar cancer would spread, possibly infecting Western Europe as a whole. This problem was augmented by the fact that the Cathar religion was more gender egalitarian, which the Catholic Church was not and would surely soon be criticised on that account, and which might result in demands for change. Although the Catholic Church has been many things to many people, a willingness for radical change has never been displayed to anyone.

What could the Church do? For a long time, it did nothing more than send missionaries into the region, trying to maintain the status quo and hoping for a breakthrough. That came in the early years of the 13th century, when Peter de Castelnau, the Papal Legate, was murdered in January 1208. Together with Arnald-Almaric, the Abbot of Cîteaux, he was trying to rally support in the Languedoc to hunt down the Cathar heretics.

In 1207, Raymond VI, Count of Toulouse, was approached for an alliance, but when he refused, he was excommunicated. Although this is unlikely

to have troubled the anti-Catholic Raymond's religious convictions, it was clear that the Church had begun to act, and some form of reaction was therefore felt to be appropriate, interpreted by some as murdering the messager, de Castelnau.

The exact circumstances of the murder are intriguing, as it occurred just after Raymond VI had apologised to de Castelnau, ending the former's excommunication. The following morning, one of Raymond's knights rode up to de Castelnau and put a spear through his body as he was about to ford the river Rhône. It underlines the fact that the status quo had been an emotional problem for both sides. Eventually, emotions would spill over; and that had finally occurred.

Learning of the murder of his own legate, Pope Innocent III ordered the Crusade on 10th March 1208. However, it took some time to rally the troops. On 24th June 1209, thousands of footsoldiers were present in Lyons to head south, under the control of Arnald-Amalric himself. On 21st July 1209, they reached the city of Béziers, on the border of the Languedoc and demanded the surrender of 222 Cathar perfecti. The condition was that if the 222 suspects surrendered, no harm would come to the rest of the population.

The following day, chaos erupted. It seems that the soldiers, anxious for a fight, decided to take matters into their own hands, and that their leaders subsequently agreed with the storming and burning of the city. Between 15,000 and 20,000 inhabitants died that day, including apparently, 7,000 people who had sought refuge in the Church of Mary Magdalene, whose feast day it was.

The sacking of Béziers was one of the Catholic Church's worst crimes, but it had its desired outcome. The news spread quickly and the movements of the Papal army were equally swift. Two weeks later, the city of Carcassonne surrendered without a fight.

It was at this time, in August 1209, that a lesser noble, Simon de Montfort, officially took command of the army. He was now "Viscount of Béziers and Carcassonne". De Montfort was a fine example of how the Church had rallied several minor noblemen into their ranks, knowing that they - if successful - would gain lands in the South of France.

By September, the campaign was largely over when most of the foot soldiers packed their bags and returned home - their 40 days required participation in return for the indulgences received by the Church had ended.

This allowed the remaining local and loyal Cathar rulers to regroup and rethink - or even just think about a strategy. In 1213, this was successful to the extent that King Pedro II of Aragon decided to help his family north of the border. However, although de Montfort's troops were

39

outnumbered by the Cathar army, they were nevertheless successful and were even able to kill the king himself. Once the king had been killed, his troops began to retreat, in the end being pursued by the Montfort's troops, who were said to have slaughtered several thousands of people.

This second disaster for the Cathars was followed by a second army. In 1216, the Count of Toulouse had raised an army that was willing to fight off the Crusaders. It resulted in de Montfort laying siege to the city of Toulouse, with several incursions into both camps. On 25th June 1218, de Montfort himself was killed when the army of Toulouse raided the Crusaders' camps. His son, Amaury de Montfort, decided to call off the siege of Toulouse within a month of his father's demise. For the first time, the future of the Cathars looked promising. In January 1224, a peace treaty was signed between de Montfort and the Counts of Toulouse and Foix. After 15 years, the Crusade was now finished... it seemed.

Nothing was further from the truth. The French king had largely remained absent in the debacle, but with the death of Philippe Augustus on 14th July 1223, the new king, Louis VIII, decided to engage. Negotiating with Pope Honorius III (himself successor of Innocent III), the two men agreed on a solution that would see the end of the Cathars. In 1226, Louis VIII's troops left for the Languedoc, to annex the property given to him by Amaury de Montfort. Carcassonne and Narbonne surrendered to the king without a fight, but on 8th November 1226, the king himself surrendered to the land of the dead.
It might have raised the hopes of the Cathar lords who had not yet surrendered to the royal forces, but their optimism was short-lived. Louis' ambitious wife, Blanche de Castille, decided to continue the crusade, in an effort to create a new kingdom for her son, the future Louis IX. Thus the French troops unleashed a "scorched-earth" tactic, burning down villages, destroying crops and driving out the local people. In 1229, the counts had had enough and agreed to sign a peace treaty. As a consequence, the Count of Toulouse was publicly humiliated in Paris on 12th April 1229 - and the Crusade was now officially finished.

The new situation would signal the end of the Cathars. Without the total backing of the local lords, they were without protection. Forced to wear a yellow cross, they were now "identifiable". In any battle, identifying your enemy is a first step towards success. Then, the Inquisition descended onto the conquered territories, with Perfects being arrested everywhere. It seems that enforcing the Catholic cause was still difficult.
Because of their particular view on life and death, many Cathars are known to have run joyfully towards their pyres, throwing themselves in

the flames, an opportunity to escape the bonds of Evil. It cannot have escaped the more intelligent Crusaders that they were actually doing those Cathars who were the most fervent in their beliefs a favour by killing them. It might also explain at some level the general absence of support by the Knights Templar in this Crusade - a topic we will return to later.

It is clear that at this time, Montségur and other Cathar castles in the Pyrenees were still standing. Not for long though...
In May 1242, two Inquisitors, the Dominican William Warnald and the Franciscan Stephen of Saint Thibéry, arrived in Avignonet to reinforce "the law" - i.e. stamp out the heretics. The local bailiff, Raymond of Alfaro, was a Cathar sympathiser and sent word to Montségur, 40 miles to the south, that the Inquisition was in the neighbourhood.
The lord of the castle, Pierre-Roger de Mirepoix, saddled up with a group of heavily armed knights, and arrived in Avignonet on 28th May 1242; they massacred the representatives of the Inquisition - in total ten men strong. Apparently, the attack occurred in the belief that the death of these Inquisitors would free the land from its religious oppressors. That would not be the case: the young king Louis IX decided to lay siege to Montségur...

Chapter 4
Montségur & the Grail

Montségur, the final stronghold, the "capital" of the Cathars, has grown to mythic proportions. Did it possess important information on the Cathar religion? Did it perhaps contain a "Cathar treasure"? There has speculation on many possibilities, reinforced by the likes of Gadal and Rahn. For Otto Rahn, Montségur was the "Lighthouse of Catharism", the Cathar Avalon; he believed that Montségur was the location of the Holy Grail Mountain, the Montsalvat. He was, says Joscelyn Godwin, "largely responsible for the mythological complex that associated the Cathars and Montségur with the Holy Grail and its Castle." Otto Rahn not only believed that the Cathars were the last owners of the Holy Grail, but that the Holy Grail "perished" when the occupants of the castle died at the hands of the "pope and the King of France" in 1244.

Gadal and fellow students of Catharism felt that the former strongholds of the Cathars, which were still available to them so many centuries after being abandoned by the Perfects, could be used in their reconstruction of the Cathar puzzle.
Although Catharism was a "Church of Love" which considered matter to be evil, many authors have argued that at the core of the Cathar religion, was a material treasure. The story goes that on the ides of March in 1244, at the end of the siege of Montségur, this material treasure was allowed to escape from its stronghold, carried off by a few faithful who scaled down the sides of the rocky outcrop, descending from the mountain and fleeing away to a safe-haven. It is rumoured that the treasure stayed in the region, in some sanctuary in the Sabarthès. This is very similar to the opinion of Rahn, which we noted earlier: how the diadem of Lucifer was placed into the bowels of the mountain, which had opened itself miraculously.
In the preferred scenario, the physical treasure was safely removed from Montségur, which of course means that this castle was not the end of the line, but that the tradition, or the Grail, was allowed to continue its wanderings.

Various locations as to where the Grail was moved to have been suggested, but the most important question that needs to be asked is of what did the treasure consisted of in the first place? Rahn considered undertaking a series of excavations in the immediate vicinity of the castle of Montségur, in the hope of finding the famous underground structures that would

contain evidence of their connection with the Grail. Rahn did not go to work like a bull in a china shop. He was a careful researcher, who obtained several interviews with a certain "Arnaud de Bordeaux", interviews which formed the basis for his belief that Montségur had been used as the shelter of the Grail.

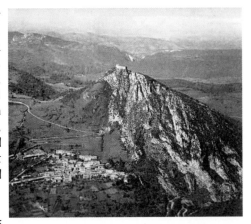

"Arnaud de Bordeaux" was an enigmatic character, some letters from whom remain in the files of Lucienne Julien. However, what Arnaud de Bordeaux stated was even more bizarre than the Holy Grail. He claimed to have proof that the Cathars had a manuscript that was incredibly rare: an original Gospel of St. John, containing the true doctrines of Jesus Christ. Arnaud, a technician who worked in a hydro-electric project in the area of Ariège, stated that he had discovered the entrance to a cave behind a pair of rocks, beneath the walls of Montségur. He planned to open the blocking stones with dynamite, convinced he would find an intact copy of the secret gospel of the Cathars. He suggested that this was the true Cathar treasure: a material book, but whose contents formed the true Gospel - the true message of the Son of God - if indeed he ever claimed to be just that.

This might come as a surprise; it definitely is much less spectacular than the diadem of Lucifer's crown or the other fabulous interpretations that have been given to the Grail. At the same time, it does coincide with what we have heard before, i.e. the sacred books given to Mani that contained the doctrine of the Egyptians. The Grail as a book is far from its traditional interpretation as a container: the cup which held the Blood of Christ. If the True Gospel was indeed written down, this bark document would be a "container" of the "True Gospel", the mechanism through which it was carried and through which the people were able to partake, by way of the "Holy Communion", of the True Message.

Rainier Sacconi, a Cathar perfect turned Inquisitor, stated that the Cathars believed that their sacred books had been written in Heaven and had been brought down to Earth. This should not come as a surprise: how else could a text be sacred to the Cathars? If written on Earth, it would necessarily have been tainted if not actually written by "Evil".

Those scholars who have studied the rise and fall of Catharism, from Bulgaria to the Languedoc, also underline that these Perfects were believed to hold the true doctrine of Jesus. It is clear that if this Gospel of John really did exist, then it was evidence that the Church had to destroy. It would sit within the same tradition as the Dead Sea Scrolls and the Nag Hammadi Library, the latter buried specifically so as to safeguard it from the Catholic suppression of the doctrine contained in the writings.

Perhaps the Albigensian Crusade can be interpreted quite logically from this perspective: a search to eradicate the doctrine that claimed to be based on the True Gospel of Christ, at the same time attempting to recover this important document. In the end, it might not have been that important whether the gospel was indeed what it claimed to be. It seems that many people believed it was original, and in religion, belief is everything.

Could Arnaud have been correct? The texts of Nag Hammadi only came to light in the 20th century. The Albigensian Crusade did away with a lot of evidence. Many of the books of the Cathars and the Manicheans have been destroyed. That little remains of these writings should not come as a surprise: a traditional feature of St. Dominic's iconography has him committing Cathar books to the fire.

It was an Arab writer, Ibn an Nadîm (who died in 995 AD) who drew up an incomplete, but nevertheless invaluable list of these books. There are references to the reincarnations of Jesus (read: his descendants) and of those which Mani evoked in his doctrines under the name of "divine substances". Some titles of these works are evocative: The Book of the Mysteries or The Greater Secrecies; the Book of the Giants, and another one The Book of Vivification. Of the third one, it would seem that only one copy was retrieved, under the name of Treasure of Life. Finally, there is the enigmatic Pragmateia, known by the Arabs under the name of the "Great Gospel", which could well have been the famous "Gospel of St John". These documents sit with others, such as the only extant Bogomil tract, the Liber Secretum or Interrogatio Iohannis, which was brought to Italy by Nazarius, the bishop of the Cathar church of Concorezzo. It became the basic text for Catharist preachers in Lombardy and even as far as the Languedoc.

Judging from the titles of these works, they seem to have little in common with the books of the traditional prophets. Only two of these books have been located, and they are in a bad state, sitting in libraries in the East. However, they suggest that rather than retelling the story of Jesus' life, they seem to be a report of a type of initiation, granting to the initiate specific knowledge.

Some sources have argued that one "lost gospel" was recovered and made its way to Berlin in about 1930. The title is believed to have been the Epistle of the Prophet, and it is said to have been destroyed during a bombardment in 1945. The question is: is it rumour, or fact?

There is an intriguing passage in Otto Rahn's book, "The Court of Lucifer". He speaks of an incredible discovery made when he was a member of the SS. He states that in the region of Fiume, in Yugoslavia, seven volumes claiming to have been the entire works of Mani, were discovered. These were immediately dispatched to Berlin for further study. It is known that the teachings of Mani were written down in seven works, believed to have been written in Aramaic: The Living Gospel, The Treasure of Life, The Pragmateia, The Book of Mysteries, The Book of Giants, The Letters, and Psalms and Prayers. Had the SS genuinely been able to recover one of the most cherished documents of the Cathars?

If it was not true, then it was Nazi propaganda, promoted by Rahn himself. Still, as we know that Rahn's integrity was very important to him - and it seems that when he found out that he or his knowledge had been abused by his SS superiors, he mentioned this to several people - it suggests that the discovery is genuine. Rahn states that the treasure presented itself in the form of broken-up fragments of something that resembled bark. He states that the writings were entrusted to the care of Doctor Obscher, whose mission it was to translate them.

However, these discoveries seem to have disappeared - "destroyed in a bombardment". The important question is what happened in between? Was Obscher or someone else able to make sense of this discovery? Again, no-one knows and Rahn himself did not live to tell.

Yugoslavia was a cradle of the Manicheic-Cathar revival of the Middle Ages. If the sacred writings survived there, could they somehow have survived in forgotten sanctuaries in the Pyrenees, as Arnaud alledged? Perhaps. Perhaps some of these books were even in the care of "watchers" who since Antiquity, had been in charge of the initiation into the secret doctrine. This might explain why Roché "knew" certain things, as he might have learned it from these "watchers", who continued to observe the tradition.

With so many questions, it is time for some answers. Let us return to the discovery of bark plates in Yugoslavia, taken for study to Berlin. Many

historians have smiled when asked whether or not this event occurred. They claim it happened too far east, and hence deem it is improbable. Indeed, if the documents were recovered, it would be an amazing stroke of luck. Furthermore, it seems that in a time of war, people would have more urgent needs than entertaining archaeological excavations. Still, coincidences to do exist and many discoveries have been made during wars - just as many other documents and artefacts have been secreted away during them.

The Germans took many treasures away from invaded territory to Germany. Much of this treasure was art - proving beyond a doubt that Nazi Germany had time to concentrate on such "mundane" matters in a time of war. Towards the end of the war, the Nazis themselves secreted them away in salt mines. In this case, many people knew the whereabouts of the booty and the Allied Forces were able to swiftly recover the stolen treasures. But just imagine a situation in which no-one who knew the whereabouts of this haul survived, and yet during an imaginary future war, some local people remember that there are salt mines and try to enter them, hoping to hide their possessions from the invading forces, or even go into hiding themselves. In this scenario, these people would have entered a mine and would suddenly have seen the vast treasures of Nazi Germany.

Continuing this hypothetical scenario, we need to imagine what might happen next. As it is a time of war, would they go to the authorities or instead try to sell or preserve the treasures themselves? Even if the discovery was made in times of peace, would the local population have immediately informed the proper authorities? Human history suggests that the answer is no. The Nag Hammadi texts were only recovered after their original discoverers thought the documents were worthless and once aware of their value, tried to sell them off privately.

However, we know that certain accidental discoveries are not accidental at all. Often, events are dressed up as an accident so that certain questions will not be asked. One such question could therefore be whether the location of these bark plates was known, and whether it was carefully monitored by certain "initiates". Perhaps the local initiates believed that their occupiers, Nazi Germany, were the ideal people with whom they should share their knowledge - perhaps they considered them to be of like mind. Or perhaps the Nazis harassed the local people to the point that they revealed the location of their treasure. We know that Rahn traversed the Pyrenees in his conviction that the Grail had been hidden there. Other enthusiasts might have roamed Yugoslavia with similar convictions.

Of course, although Montségur might have contained the "True Gospel"

of Christ, it is clear that the Cathar Perfects must have had either copies or synopses of this central message, to help them in their mission. Though the "original" Gospel might have been in Montségur, other regions or countries must at least have had complete copies. In short: there must have been copies of the "original gospel". This might explain why certain discoveries were made in Yugoslavia, and others were searching in the Languedoc.

It is clear that sending a squadron of armed Nazis towards Montségur or Tarascon in the Ariège would have been a bad move on their part. It would have exposed their real motives and it would have meant that the Resistance would quickly have been able to gain new adherents. It would reveal that the German occupying forces were looking for something, "something" which had nothing to do with the war, but which was perhaps even more important.

If the Cathars were indeed agents of the Grail, as Rahn believed, then it is clear that they could also have been messengers of the "True Teachings", the Grail, which granted Divine Knowledge. Those who lived in the neighbourhood of the Grail were said to have been immortal; those who received the consolamentum, were said to become immortal, once again to become one with God.

Whatever the Cathar Perfects knew, they never revealed anything under the torture of the Inquisition. To some extent, the Church should have known they would never reveal it under torture: they considered the physical world to be evil and as they were the "high priests" of their religion, they were the most fervent followers and believers in this cause. Any torture the Inquisition inflicted on them merely proved to them how much the physical world was the symbol of pain and evil; with every stroke of pain inflicted on them, their soul was liberated more and more towards the God of Good.

In this scenario, the relationship between Gadal and Roché on one side and Rahn on the other is intriguing. Rahn was obviously a man with a mission, working for a superior. Gadal seems to have been a solo artist, who tried to promote his region in the pre-war days and unfortunately might have been "played" by Rahn. What about Roché? Was he just a student or was he an initiate, even reporting to "unknown superiors"? Whatever the true picture, it is clear that during the Second World War, the playing field changed. Although Rahn's action might have been forgotten by the locals, it must have been difficult for Gadal and Roché to discuss him. They might have wondered if their interest was shared by the occupying forces and if they were specifically "earmarked" for special treatment, whether that was negative or positive. But it is clear that Rahn's interest transformed the entire Cathar conundrum and might have

Some of the bark pages discovered in Montsegur

elevated it to a matter of state, in Nazi Germany. If parts of the German government did assign a workforce to the cracking of the Cathar enigma, did they ever unscramble it? Who knows?

Could the true treasure of Montségur have been a secret doctrine, a sacred text? Did the men who allegedly escaped from Montségur, taking the Grail with them, perhaps take bark panels into safety?
If the story of their heroic account is based on fact, then these men were working under tremendous circumstances. The papal forces had surrounded the stronghold and only by risking their lives was there any chance that they might escape the soldiers' attention.
Even so, the chances of their survival were small... their chances of being caught were high. What would happen if they died or fell victim to the papal forces, with the treasure on them? It would have been a veritable nightmare. Furthermore, who would have come up with such a dangerous plan? Who would dare to gamble everything? Perhaps we need to ask whether only a part of the Cathar treasure was handed over to these men, whereas the other part might have had a different destiny.

This is not idle speculation, for we have proof that part of the treasure remained in Montségur. We have that proof in our possession. It is a discovery that was made forty years ago, when a case was found in a wall of the castle of Montségur. The man who found it insisted that his name was kept confidential. We are, of course, in a domain where "the law" is extremely grey...

The discovery was made during preparatory work done in the castle for the first session of cleaning work, as part of making the castle suitable for the large influx of tourists. This work involved the strengthening of the masonry of the walls and thus involved a location that had intrigued Rahn, and Arnaud of Bordeaux.

The exact location is difficult to pinpoint exactly as our contact himself was not specific about it. Most likely, it was a major wall, on the left hand side, close to the main tower, in front of the entrance of the castle. Whilst trying to remove shrubs that had taken root in the walls of the castle, he found a container that was still sealed and which was found virtually intact between the stones. Inside was a batch of fine plates, covered in signs, drawings and writing that is incomprehensible. We were allowed to make photographs of this collection and showed it to certain specialists, who stated that the language was indeed unidentifiable. It is clear that this discovery is very similar in nature to the bark plates that were found in Yugoslavia, which also contained incomprehensible writing. The total number of plates found in Montségur is difficult to assess. They were divided into three lots, as there were three people present when the discovery was made. Most likely, the total number of "pages" was between 12 and 15.

Unlike the Yugoslavian discovery, the Nazis did not find this deposit, although Rahn must have passed very close to it. If these plates are indeed the "Cathar treasure", either the whole or a part of it, then it is clear that by prudence, the old walls of the castle have sheltered it for many centuries, waiting for it to be rediscovered.

Some final questions remain: did Roché know it was stashed away there? Did Gadal and Rahn suspect it? All we know is that the three men did meet and had exchanges on the subject of whether or not the castle still retained "the Cathar treasure". It is clear that it did.

49

Chapter 5
The Grail Castle ?

If you read the books of Otto Rahn, Antonin Gadal and Déodat Roché, you are left with a convergence of ideas that seems to indicate that they believed or knew that the Grail had been deposited elsewhere in the Sabarthès. This had resulted in criticism, as nowhere in their writings do they prove their assertions. Did they invent the entire sequence of events? Or were they unable to tell everything? Few critics have pondered the latter question.

Although we know that something survived, i.e. the bark plates, these survived in the castle itself. It does not tie in with the assertions made by Gadal and Roché, who argued that the Grail was removed from Montségur to a new safehaven. Therefore, we need to return to the castle of Montségur and try to retrace the last stand of that castle, along with the possibility that "something" was removed from it, and to where it was taken.

16th March 1244 signalled the end of the lives of over 250 people. Far more people have died in a single day and place, but these people are remembered continuously. They were the last Cathar sympathisers of Montségur who made a stand against the Papal forces. The Cathar furnace that burnt on top of the Pog de Montségur consumed women, soldiers and men, some of whom had requested the consolamentum as the final communion. They preferred to die, rather than disavow their faith.

How the Papal forces made their way to this location is well-known. Various nobles had followed the call of the Pope to defeat the Cathars, demanding their surrender in various villages and castles, leaving a trail of burnt soil behind them across the Southern French landscape. It was the first time a Crusade had been carried out against one's own people, and it signalled the start of a decline in morality - and paved the way for several more religious battles that would scorch the grounds of Europe in the coming centuries. Wars were still about territory, but in Europe, they had become inspired by religion.

But underneath what is known, there are, as always, items which are not known or hardly so. One such question is whether Montségur was indeed the "capital" of the Cathars, a sacred centre of their religion, or was it merely their last refuge (though not the last castle to fall)?

Several discoveries attest that the site had been occupied by our early ancestors. At an altitude of more than 1000 metres, it offered an easily

defendable refuge with 360 degrees of vision. Furthermore, the place has some charm - or magic - about it, which must have impressed our forefathers and might have persuaded them that it was imbued with "divine energy". Coincy-St-Palais proposed that the place had been dedicated to Bellessema, but that the local deity was supplanted by Mithras when the Romans arrived on the scene and built a temple to that deity on the site.

In Visigothic times, the site was believed to have been controlled by duke Waïfre and as late as 1930, there was still a tradition that mentioned a "Peak of Hunald", the father of Waïfre. Nearby, several funerary places dating to the Visigothic era have been found. In 1953, Dr. Morant found several traces of metallurgy: moulds for axes, other weapons and especially bronze decorations. Though intriguing, none of these finds are extraordinary.

The "sacred aspect" of Montségur is specifically linked with the Cathars. When the Albigensian crusade began in 1209, Montségur was already a Cathar stronghold and many came to learn, if not to become a Perfect. It is believed that approximately 200 people lived on the Pog. According to a deposition given to the Inquisition on 30th March 1244 by the captured co-seigneur of Montségur, Raymond de Pereille (b.1190-1244?), the fortress was "restored" in 1204 at the request of Cather Perfecti Raymond de Mirepoix and Raymond Blasco.

The site remained relatively free of any problems, though it must have been hard to hear how friends and family were slaughtered elsewhere. When the Treaty of Paris was signed in 1229, the Cathars were officially without local support. In 1230, the leader of the heretics, Bishop Guilhabert de Castres, asked Raymond de Pereille for permission to make Montségur the seat of the Cathar Church.

Two years later, in 1232, the Cathars asked Raymond if they could live within the castle. Montségur was thereafter gradually fortified and various adjunct walls were constructed along its southern and northern slopes. With the torrent of Cathar refugees and clergy arriving at Montségur, a small terraced village grew in size beneath the fortress walls on the north-eastern flank.

In 1234, Raymond Pereille's dispossessed cousin, Pierre-Roger de Mirepoix arrived at Montségur. His father was Pierre-Roger de Mirepoix le Vieux, co-seigneur of Mirepoix and brother of Guillaume-Roger de Mirepoix, Raymond de Pereille's father. Pierre-Roger was accompanied by his relatives, knights and men-at-arms and married Raymond's young daughter Philippa. With the marriage, he became co-seigneur of Montségur, and then he, not Raymond de Pereille, assumed most of the administration and defense. It was after the assassination of the Papal Inquisitor by Pierre-Roger de Mirepoix that Blanche de Castille ordered

that the "head of the Dragon" had to be cut off: Montségur had to be destroyed and the heretics had to burn.

It took one year, until May 1243, before the crusaders finally laid siege to the Pog. An army of no less than 10,000 men, under the command of Hugues d'Arcis, signalled the intent of the Pope. The Cathars had a defensive force of 100 soldiers, supported by some knights. In total, the Pog was home to 500 people. Even though they were outnumbered by twenty to one, the Pog quickly proved to be impregnable. As a result, psychological warfare was opted for. Every quarter of an hour, the French troops would hammer balls weighing up to 80 kilograms into the ramparts, making life inside the castle a living nightmare...
Still, the siege continued and it was the end of February before negotiations about the surrender began. The terms offered were astonishingly flexible:
- on surrender, the castle would be yielded to the crown of France;
- the war troops defending the castle would be allowed to leave as free men, their weapons and luggage intact, although they had to recognise their errors;
- those who would disavow their heresy would be reconciled with the Church;
- the Cathars would also be reconciled, but would have to undergo heavy penance, whereas those who did not disavow their faith, would be burnt.
Raymond-Roger was given a fortnight to return to Montségur before the deadline of the offer was up. This meant that the Cathars had a "period of grace" of 14 days wherein there would be no battle or intrusions in their castle. The fact that this period of grace was granted so very easily will remain an enigmatic topic for the historians debating the end of Montségur.

It seems that this long period of grace was requested by the Cathars themselves. Some authors have argued that they were waiting for a specific date to occur which was of great importance to them. Indeed, the period of grace meant that the deadline was set for 16th March. Because of inconsistencies in the calendar, in those days the spring equinox fell on 14th March (corresponding to our 21st March). For the Cathars, it was also the festival of Mani and thus the most important day of the year. Either the Papal troops were unaware of this festival, or else they allowed their opponents the liberty of preparing and holding what could only be described as an heretical communion. Once again, it would underline that nothing in this war was black and white.
If the spring equinox was indeed what the Cathars were waiting for, then nothing could be better suited for that than the castle they were in.

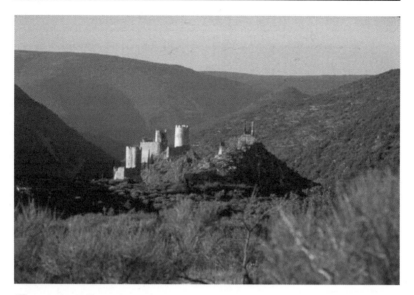

The castles of Lastours

Montségur was ideally suited as a temple where the observations of the skies were important. If the spring equinox was important to the Cathars, it is only a small step to ask whether the other dates of the "solar calendar", such as the solstices and the autumnal equinox, were equally important to them.

As a consequence of this possibility, several researchers have tried to find out whether the Cathars had aligned parts of their strongholds towards the sunrises or sunsets on these specific dates. This would place their strongholds firmly in the category of a religious temple, in the same category as monuments such as Stonehenge (as well as other megalithic monuments), and also certain Egyptian temples.

Research suggests that there were at least three "solar sites" that were important to the Cathars: Montségur, Queribus and one of the four castles of Lastours, Cabaret.

Lastours stand on a hill crest above the village of Lastours, flanked by the River Grésilhou to the west and the River Orbiel to the east. The castle is an unusual arrangement of three castle towers (Las Tours, The Towers) that belonged to the Lords of Cabaret, who held it in fief from the Trencavels. The three towers were called Cabaret (to the north), Quertinheux and Surdespine (to the south).

One of these towers is a five-sided tower. There were only four archer holes to allow for lighting and any defensive use. Two holes are set

directly south, one to the west and the fourth to the southeast. The vertical axis of the archer's hole is directed to the rising sun, from the 19th to the 26th of December - the Winter solstice, the sign of the rebirth of the sun.

Quéribus is sometimes regarded as the last Cathar stronghold. After the fall of Montségur in 1244, surviving Cathars gathered here. In 1255, a French army was dispatched to deal with them, but they slipped away without a fight, thus not really being in the same league as Montségur. Even today, the solar phenomenon can still be observed. It is witnessed at dawn on the winter solstice, inside the "Gothic Room".

But what about Montségur itself? There, the archer holes of the keep allow in a pencil of light at dawn, which leaves a mark on the opposite wall. Although some people might consider this to be a coincidence, it is equally true that in all three locations, this extraordinary spectacle of light can still be observed. And if it is not a coincidence (which we would suggest it is not), then it is clear that the Cathars were indeed interested in the solar phenomena.
This should not come as a surprise. It is known that they considered the sun to be the symbol of the God of Good. But within the same context, it needs to be made clear that the Cathars thus also identified themselves with a tradition of solar worship, which can be traced back to the very beginnings of time, which incorporates not only the Pyramid Age in Egypt, the Megalithic Age in Europe, but also the Inca Empire in Peru -

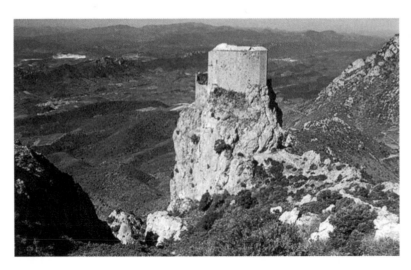

The castle of Queribus

54

in short, a global phenomenon that dates back to the origins of Mankind. Again, we need to consider whether the intriguing measurement equipment of Mr. Lawrence had anything to do with such solar observations.

Still, we have strayed from our original question, which was whether there was a link between Montségur and the Grail. However, the digression is important, for surely a holy relic such as the Grail, whatever its nature, would have required a "temple", rather than a mere "castle".

Two facts are undeniable:
1. The Cathars had gathered an amount of monetary valuables, which was required to sustain them in their daily needs: food, certain material and unforeseen expenses. This was received largely from supportive landlords.
2. The Perfects would shelter what to them had a single and paramount spiritual value. These could be physical objects, but also books or documents.

Could this be the Grail? There is no doubt that Wolfam von Eschenbach talks about a castle in which the Grail resides. He refers to it under its Occitan name: Montsalvage, or Montsalvaeche, which is not too dissimilar from Montségur - but dissimilar enough for it to be straightforwardly equated with the Cathar castle, as some authors have done.
There are more intriguing coincidences. We find that the first owner of the Grail is a king known as "celui qui tranche bien", i.e. Trencavel, and Trencavel is the patronym of Raymond, Count of Foix, the "king of Montségur". The lord of Montségur is one Raymond de Perella, which corresponds closely with the "Parilla" identified in the Grail document of von Eschenbach.

There are several accounts which link "a" Grail to this area. A letter of Saint Laurent, dated to 258 AD, attests that he transported the Grail to Huesca, in Aragon. In 713 AD, Audebert is said to have transported this object to San Juan de la Peña, on the other side of the Pyrenees. Legend has it that in order to protect the Grail, it was taken to another area, to a manor house "on the rock", North of the Aragonese Pyrenees.
The tradition states that Pedro II, king of Aragon, husband to the daughter of the Count of Montpellier and father in-law of Raymond VI, Count of Toulouse, appointed a knight who was loyal to the Cathar cause as its protector. This knight would have been Trencavel, the Parsifal of Wolfram von Eschenbach. It is claimed that he followed the valley of Seyre, to join Puymorens; that from there, he passed through Ussat, then Ornolac,

Montréal-de-Sos and arriving finally, via St Barthélemy, at Montségur. However, this is just one of several traditions that report that Montségur was the final shelter of the Cathar treasures. But the central question is whether these treasures are identical to the Grail. And whether or not they are, what can they be that they ignite the hopes and imagination of so many?

As if the problem is not complex enough already, there is another rumour that there was an important funeral deposit under the castle, containing the remains of certain notable Cathars. One account argues that the delay of the surrender of the castle was required so as to erase all traces of the access to this sanctuary.

Confronted with so many potential treasures, let us look at two testimonies. The deposition of Imbert de Salles reads: "Pierre Bonnet and Matheus left the castle with gold, money and a great quantity of currency." This occurred in early 1244, when the precarious position of Montségur compelled the evacuation of the first part of the precious deposit. The depositor stated that they fulfilled their mission and were able to bring their inestimable treasure to a safehaven.

This evacuation followed Christmas 1243, when, as the result of a betrayal, the situation of the besieged Cathars suddenly became very alarming after the crusaders had taken possession of the sector along the East tower. It was in early 1244, when a messenger brought Pierre-Roger a missive from Raymond Niort: a light signal would be sent if "the Count of Toulouse carries out his mission well". The following day, the signal was sent - but what did it mean? The signal might have been related to the evacuation of the first part of the treasure. The same Niort seems to have intervened in the terms of surrender that occurred in the beginning of March 1244.

The other account argues that on 16th March 1244, when those Cathars who had not disavowed their belief were led to the fire, four men left the castle in great secrecy, the castle itself now left virtually unguarded. These are four important men: Hugo, Poitevin, Amiel Aicard and a fourth whose identity is doubtful. Arnaud-Roger de Mirepoix would affirm to the Inquisition that it "was accomplished so that the Church of the Heretics would not lose its treasure". This last effort was orchestrated by Pierre-Roger de Mirepoix himself and although the undertaking was extremely perilous, it was apparently successful.

It is clear that this last removal could not have involved a monetary treasure. That had been evacuated almost two months earlier. Moreover, evacuating such a significant quantity of currency on the back of a man while going down a cliff at night would be an impossible feature. It is

therefore clear that what was being placed into safety was something that was relatively small in volume, not cumbersome to carry around, but which was nevertheless invaluable in the eyes of the Cathars, who wanted to preserve it until their last night in this realm. It suggests that the relic was therefore of prime religious importance. It seems also likely that it was required for their celebrations of the spring equinox festival, if not for the final preparation for their death - which would mean that the artefact played an important role in the consolamentum. If not, they would have been able to remove it earlier.

However, in spite of the earlier evacuation of a treasure, it is known that certain valuables did remain in Montségur. We know this through the testimony of Pierre-Roger de Mirepoix, who, at the end of the fortnight of grace, received a coffer that was filled with money. For his part, Imbert de Salles received money from Bertran Marti, as a thank you for his devotion.

Certain recent discoveries have added substance to the medieval accounts. Between 1930 and 1935, Arthur Caussou, a very wealthy person living in the area, was extremely interested in Montségur. He explored the Pog's every little nook and cranny and he ended up making a fortunate find in a small cave on the mountain slope. He found two small, sandstone pots. The first apparently contained a small white stone dove. The second held approximately 200 gold coins, money dating from the 13th century. Two scientists, Glory and Durand, drew up an inventory of the find and submitted the discovery to experts. However, this scientific discovery was also the instigation of a legend, which stated that from the day of his discovery, Arthur Caussou began to lose his fortune and eventually died a ruined man. "The only things he was able to leave his heirs were the old coins and the small white stone dove."

The final aspect of the story truly is a legend, stating that a share of the treasure still remains within the bowels of the "mountain of Thabor". It is said that the access to it is only possible during mass on Palm Sunday, at which time the mountain will reveal a passageway to the precious deposit. The account states that the treasure is protected at all times, and that those not worthy to find it, are in great danger if seeking it. This legend must no doubt have impressed Otto Rahn...

Raymond Niort was a key figure in the surrender of Montségur, on good terms with the master of the castle, and apparently involved in the removal of the "precious deposit". Shortly after the fall of the castle, Niort was asked to appear in front of the king, Louis IX, who seemed to do his utmost to treat his visitor with the greatest respect. On this visit, Niort discreetly gave the king two boxes and the "two large registers",

57

which nobody has since been able to trace. The only glimmer of hope in this puzzle dates from 1623, when Henry Banemau thought he had solved this enigma, claiming that this "donation" had ended up in the monastery of Usson. If true, then it is intriguing to note that the king, who laid siege to the castle, was the one who, in the end, received the deposit. We do need to consider what the boxes and the registers might have contained and ask ourselves whether this is the real reason why the terms of surrender were so lenient.

In light of the discovery of the bark plates, we should question whether the stories of a deposit smuggled out at night are indeed too good to be true - a smokescreen for the truth, perhaps created by the owners of the deposit themselves. Could the treasure have been hidden underneath the castle itself?

There is a strange stand-off when this question is addressed. On the one side are the scientists, who are adamant that there are no artificial (i.e. man-made) underground structures or cavities under the castle. But this is in direct contrast with a legend, which argues that during the surrender, Pierre-Roger de Mirepoix hid four volunteers, who evacuated the second part of the treasure. It is a legend, but surely a legend would not create an absent underground structure? Is it not more logical to assume that the underground structure has so far not been discovered? Just because it has not yet been discovered does not mean it did not exist. It might just show how well-hidden it was.

This is not mere idle speculation. Another tradition says that Ramon de Perelha allowed the "bons homes" to meet "under the walls of the castle", so that they could celebrate their faith, in spite of the crusade. This is what was reported by Guillaume Tardieu: "the preachings of the deacons were held in a room under the walls the use of which was reserved solely for this purpose..."

Perhaps the underground did not lend itself naturally to the construction of a gallery, as was attested by Mr. Popper, but working on a natural hole underneath the castle would not be that difficult. And there are many such natural holes underneath the castle. The best known is that in which the corpses of victims of the last assault against the catapult of Bishop Durand were thrown.

There are also known caves on the slopes of the Pog, such as the cave of Tambour. Certain authors believe that the name is a corruption of TABOR, which would correspond to the old name of the mountain St. Barthélemy. However, others see it as deriving from Tabour or Tambur, i.e. Arabic, and indicating a musical instrument. These possibilities aside, there is a Cathar cross clearly engraved on the wall of this cave - suggesting it might have been used by the Cathars.

Another less well-known cave is the cave of "fusil", the rifle. The origin of the name is never discussed, though it could have been another shelter for our escapees.

Apart from these two cavities, it is clear that Montségur was a place where people lived. And an inescapable event of life is death. Many people decided to go and live up on the Pog, indeed many sick people went up the hill when they were ill, and many died there. As the most important part of life in a Cathar's belief, was death, an event that had to occur in the presence of a Perfect, of which there were many at Montségur, there would be more dead bodies in Montségur than would normally be expected.

We also know that many people died during the siege. All of these dead bodies had to be disposed of, specifically during the siege when those inside the stronghold had limited mobility. Therefore the obvious question that needs to be asked is where the dead bodies were buried. Although cremation might seem to be the obvious answer, it is known that the Cathar religion did not allow for this; it required the dead to be buried in wooden coffins. Even if the dead were buried around the castle, the crusaders would surely have unearthed them during the siege, while filling up the pits and coffins with new dead? And even if the crusaders left the dead alone, the archaeologists would have found them during their excavations.

As none of the above scenarios seem to have occurred, there is a small enigma. At the beginning of the siege, there were 150 soldiers, and 350 other people: 500 people in total, some old and some invalids, others young. At the end of the siege, there were 210 Cathars, the lords and his closest family (approximately 20 people in total), the remains of the garrison (a maximum of 40 people) and 6 escaped volunteers: a total of 280 people, which we will round up to 300. This means that 200 people are unaccounted for and we might assume that they died during the siege. Unfortunately, there are no records on the number of dead during the siege. But it is clear certain people must have died and although it might not be as much as 200, at least it should be a few dozen. But only 4 corpses were ever found, at least that are known through the records, and these succumbed during the last ditch struggle against the crusaders' catapult.

However, the most remarkable aspect of this problem is that our "enquiring" scientists never seem to ask this niggling question. Still, it is clear that at least 50, possibly 80 and a potential 200 or more bodies if not coffins are missing from the scene. They had to be buried somewhere and with nowhere to go except inside the castle, it might seem logical

once again to assume that under the castle, natural or artificial cavities do exist, which were used as a necropolis.

To this we need to add a strange account, dating from 1935, when a certain Mister "B", accompanied by Bishop Durant, made a curious discovery in a cave near the Tambour: a strange bowl-shaped cavity which they explored. They were able to walk for a good distance, to where the gallery lead towards a room where they discovered some strange remains and two "corridors" that rose, but which they did not have time to explore in detail. Were the two men genuine, dreaming, or hoaxers? Whatever they were, "B" reported the find to the G.R.A.M.E. (Groupe de Recherches Archeologiques de Montségur et Environs) and the mayor of Montségur. It seems that he was taken for a dreamer and that there was no follow-up to the discovery. But there are two accounts of similar observations in this sector of the Pog.

Finally, there are the strange figures, some of which are geometrical, in documents that were discovered around 1935. It seems that a depression in a part of the wall caused the discovery of their hiding place. The first part of the document was illegible, except for one word: "Fate". The second part consisted of "thicker parchment covered with figures and geometrical figures". The whole body of texts appear to have a Hermetic origin.

More recently, during the winter of 1996, some researchers flew over the Pog in a small aeroplane, to take images with infrared photography. The resulting images proved that there are several cavities inside the hill which have not been discovered so far. Two echoes were particularly important, as they were within the area of a very thick wall; another was in the perimeter of the keep. This should not come as a surprise. The region in the immediate vicinity of Montségur, the Lasset Valley is densely laced with deep and complex cave formations and underground river sources. It will be left to the future to witness whether or not there will be definitive proof of the existence of more underground structures underneath the "Castle of the Grail".

Chapter 6
The Wanderings of the Grail

The evidence so far suggests that whatever was hidden in Montségur was moved from the castle during the period from March 1243, in the months, weeks and even days before the end of the siege. Numerous stories have been written about this, but the most famous is probably that told by Gadal. Gadal believed that it was one Bonnet and a deacon, Matheus, who were in charge of this mission. He believed that the deposit was divided, with the first part hidden in the wood of Sénélongue, the second in the caves of the Lombrives.

On the same day that Montségur surrendered, Bertrand d'En Marti entrusted Amiel Aicard with a certain number of documents and the "Symbol of the Desire of Paradise". Gadal and Salans d'Artaran interpreted this as a cup that was surrounded by an incredible history and that "shone, even through a bag made of goatskin". From here to the supposition that this could be the Grail is but one small step, which many have taken all too rapidly... Apart from that observation, the marquis d'Artaran, as well as Napoleon Peyrat, the Protestant pastor of St Germain-en-Laye, stated in "Histoire des Albigeois" (1870) that Amiel Aicard and three other Perfects found refuge with sympathetic knights, in the caves of Lombrives, and were preaching as late as 1270.

Gadal has been ridiculed, but Glory was a respected professor. Thus, what are we to make of this statement by A. Glory: "thus the militia of Templars, scattered across the world, always preserved the mysterious virtue of the Grail, reserved for the Perfects of the Middle Ages."?

Glory and others tend to fall into a category of determined researchers who have continued their researches into the enigma of the Cathar heartland. All of these would attest that there remained certain people who spoke of the existence of a "Grail" in this area. It took these researchers many years to find people who were willing to talk, as well as documents that might support their conclusions. In retrospect, it is unfortunate that these people were originally approached by Germans, this in pre-war days. It is unfortunate in more than one way: not only did it mean that their research was politically tainted, but also that any material given to the German researchers was either lost during the Second World War, or disappeared from the scientific forum into a political climate. This meant that authors like Gadal have been ridiculed, often without any substantial reason.

The list of people who were interested in the original research of Gadal, Glory and Roché is long: Karl Rinderknecht, a graduate in history from Switzerland; Walter Birks, His Majesty the King of England's attaché; Nieberding, a scientist of the Belgian C.D.R.H; professors Paronelle, Bonteaud and de Cassan of the University of Paris and of course the infamous Otto Rahn, member of the SS. All have spun variations on the basic theme, which is that the Cathars who saved the last part of the Cathar treasure, deposited the precious material in a "Castrum de So". It is suggested that they followed the paths that lead over the slopes of Lujat, towards Ornolac. There are further allegations that Pierre-Roger de Mirepoix took another part of the relics to the castle of Montaillou, and from there to Usson, a location we have come across already.

Another important location in this "tradition" is Miglos, approximately 5 kilometres from Ornolac, and 13 kilometres from Lordat. Miglos itself has existed since 1136, since Guillaume d'Arnave joined the Templars, resulting in the foundation of the commandery of Capoulet-Junac. We should consider whether this commandery might be part of the story, as it is situated between two locations to where the "Grail" was said to be taken. Specifically the statement by Glory and others that certain knights remained loyal to the Cathar cause and safeguarded their treasure is important. This would make the commandery of Capoulet-Junac the ideal location - and would identify the "knights" with the Knights Templar who in legends, are often connected as the guardians of the Grail.
How unlikely is this? It is a fact of history that the Knights Templar refused to take part in the Albigensian Crusade. This was a very important decision, as it was the Pope himself who ordered the crusade - and it was to the Pope alone that the Knights Templar reported. Furthermore, some knights actually protected certain Cathars: Pierre Fenouillet allowed Cathars into the commandery of Mas-Déu, in the Roussillon, a commandery linked with the Templar house of Le Bézu, near Rennes-le-Château. Moreover, in less than one century, the Templars themselves would become the subject, and in the end the victim, of an enquiry that charged them with heresy.

The allegations of heresy that were levelled against the Templars were all totally bogus and created by the King of France's henchman, Guillaume de Nogaret, who also claimed that Pope Boniface VIII had been guilty of heresy. He surprised Boniface in his palace at Anagni in and arrested him on 7th September 1303. The inhabitants rescued the pope and it was only Boniface's death a month later that prevented Nogaret from receiving severe punishment. Philip then sent him to the new pope, Benedict XI, who refused to absolve de Nogaret from the excommu-

nication he had incurred. That would last until 1311 when he was finally absolved by Clement V.

On 22nd September 1307, Philip made de Nogaret keeper of the seal and that same day, the Royal Council issued a warrant for the arrest of the Knights Templar, which was executed on 13th October; Nogaret himself arrested the Knights of the Temple in Paris and drew up the proclamation justifying the crime. Obsessed with upholding the supremacy of the French king, Nogaret planned to launch a new crusade, blaming the loss of Jerusalem on the Templars. The cost of the new crusade would be born by the confiscated goods of the Order. He also argued that only Philip the Fair would be successful in achieving the success of this crusade.

The Templar commandery of Capoulet-Junac blocked the valley of the Sos, but it is difficult to see how this fortress ensured the safety of the access route to Puylaurens, which according to the official versions of history, was the commandery's sole mission. If anything, its location would result in the slowest response time for any required intervention, thus

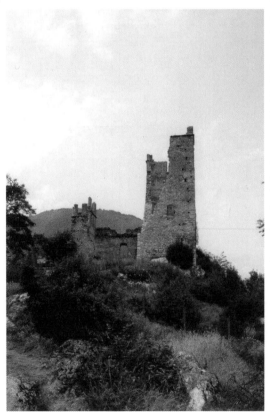

seriously questioning its effectiveness and fitness for its purpose - unless its purpose was different from that of the official version of history. If we assume that the fortress was indeed built to defend something, then the only thing it could defend is the town at the bottom of the valley: Olbier, or Montréal, with its fort, its underground caverns and its strange legends as the final resting place of the Grail.

The remains of the Templar commandery of Capoulet-Junac

63

Some accounts argue that the fortress of Montreal was the true Templar commandery, with Capoulet as a garrison serving as a first line of defence. This fortress, impregnable and never taken, would still be standing, if Richelieu's hatred of the feudal past, the independent glory that it represented and the idea that it could be reborn and be enemy number one, hadn't had it demolished. A section of wall is all that is left on the mountain.

The writings of Coincy-St-Palais are in line with those of d'Artaran on this account. Both authors wondered about the true destination of the castle. Both mention the existence of an ancient crypt that would serve as the place of initiation of the Guards of the Holy Grail. D'Artaran proposed that only twelve knights occupied the fort and he identified these knights with the twelve valiant knights that were said to guard the Grail.

All of the above scenarios argue for a "Superman" rescue of the Cathar treasure at the very last minute. But few researchers seem to have raised the possibility that should have come to their mind. The people in Montségur knew that a crusade against the Cathars had occurred, and that no Cathar, let alone a Perfect, was safe. This meant that even though Montségur was left untouched for the whole period of the campaign, once the Church had its Inquisition hunting Cathars, the danger continued. Thus, safeguarding their treasure should have commenced before the siege of Montségur began, as in essence, by then, it would be too late. So either the Cathars were stupid, thinking perhaps they could defend their treasure, perhaps they needed to have it, or perhaps they put it into a place of safety before the siege of Montségur. The latter possibility would

greatly reduce the risk of it falling into enemy hands, as a result of military strength, treason, or any other means.

But let us assume the traditions are correct and the long and risky route was indeed the fate that befell the Cathar treasure. Why would they have chosen this difficult route to safety in the Sabarthès? The only likelihood seems to be that somehow, the Perfects of Montségur were assured that they would be able to reach their destination safely. And this could explain the enigmatic "signal" sent during the siege of the castle.

But there are other clues that a daring rescue was indeed the modus operandi. One significant detail is that one of the defenders of Montségur is none other than Arnaud de Miglos. He was locked inside Montségur as one of the defending soldiers. He was one of those who would be imprisoned in the dungeons of Carcassonne, together with Ramon de Pereilhe. But curiously, he was not amongst the warriors that were given a slap on their wrist and then released. Quite to the contrary: he died in captivity, under quite curious circumstances. Did the Inquisition believe Arnaud knew more and thus condemned him to the dungeon, in order to force him to reveal elements of the secret he was keeping? As a side note, the de Miglos family had a strange alliance with the descendant of a nephew of Pope Clement V, Bertrand de Goth, the pope responsible for the demise of the Templars. Could this be a coincidence, or might it be part of the same design?

Finally, the writings of a "Cave of Initiation" refer to a cave which is the only one of its kind in the world. Situated at an altitude of approx. 1,200 metres (3,600 feet), the small cave sits on a narrow cornice, in the axis of the sun rising on the morning of the summer solstice. This is remarkable and would identify the cave as a possible sacred site. Furthermore, it would mean that the cave is naturally aligned to solar movements, which the Cathar architects incorporated into the designs of some of their strongholds.

It is definitely a corner of a grand room of initiation, for, despite the ravages of the weather, one can still see the famous panels in three colours, sung of by Percival and Chrêtien de Troyes. One can distinguish a broken sword, a lance, a platter adorned with five drops of blood and in the centre, the famous Holy Grail, the form of a resplendent sun, and a vestige of the crown of thorns. These symbols are impressive, given their esoteric character.

The painting was first seen by the historian Adolphe Garrigou, who mentioned it to Gadal in 1893. Gadal and Garrigou had an intimate relationship, the young Gadal often reading aloud to Garrigou, whose vision had deteriorated dramatically late in life. In 1910, Gadal made his first sketch. Mr. Becq d'Auzat, who also knew of its existence, showed it

to Dr. Cannac in 1930. Mr. Rouzeraud, the school principal in Vicdessos, and Mr. Clasters spoke to Mr. Mandement, who published three articles on the subject in the Dépêche de Toulouse. André Glory was sent to investigate by Mr. Béguoin, director of Prehistoric Antiquities of the South. Glory made a full-sized copy of the painting on 23rd July 1943, and thus discovered the "crown of thorns".

Although the details are often difficult to discern today - vinegar helps - the "curious signs" are still there and can be seen by anyone wishing to contemplate them. Indeed, inside is a silky polished stone, on which human beings have knelt for centuries. Opposite, to the right of the visitor, is a kind of step at the base of a smooth, vertical part. Gadal, Glory and Joseph Mandement, president of the Syndicat d'Initiative of Tarascon, all stood here and admired them, and left behind detailed drawings of how they appeared in their days.
The immediate access to the cave is special also: you cannot walk straight from the cornice to the paintings, even though they are visible. Instead, you need to slip inside by a ventilation hole, either crawling on your knees, or with arched back. All these poses express humbleness, and are crucial stages for any initiate. Hence, to see the paintings, everyone is forced to be humble before they can stand in front of them.

The drawing itself forms the core of many pilgrimages by the "Haarlem Rosicrucians", a Dutch movement of people that consider the cave to be their "Mecca". Officially known as the Lectorium Rosicrucianum, they were founded in 1952 by J. van Rijckenborgh (real name: J. Leene) and Catharose da Petri. To them, the castle and the drawing are the true "Grail". In 1982, they translated and published the book by Antonin Gadal on Montréal-de-Sos, entitled "The Grail Castle".

So what does the drawing depict? With a chalice, a spear and the other instruments of the last moments of the life of Jesus, it is clear that all the symbols of the Grail have been brought together in one painting. It seems logical to assume that this picture functions as a "memorandum" of what the treasure itself represents and it is this conclusion that Gadal and others drew. Their theory was reinforced when we note some of the other discoveries that were made by researchers during the 1940s: blocks of gold coins amalgamated with the limestone, and old religious artefacts, placed in the calcite castings. Therefore, even though the site is important, the question is whether it is indeed "the" destination site of the Cathar treasure that was spirited away from Montségur, or whether it served another purpose.

Montreal-de-Sos, with the castle on top, and the cliff face containing the cave

Certainly, the location would definitely be an area where the Perfects could hide during the turbulent 13th century. But is it the most likely destination of the Grail? That is doubtful, despite the conviction and dedication of Gadal and others to this site.

Whatever was taken from Montségur, it was definitely not pots of red, black and white paint to create this painting. Whatever was taken was something else. Wherever it was taken, it was not to this cave.

There are several castles along the Pyrenean frontier that could have been chosen and the one which would have had the most chance of holding this treasure would have been Usson. The castle of Usson-les-Bains, 81 km south of Carcassonne, was the key to all the Pyrenean and Iberian passages. Constructed in the 11th century, the castle was given to Raymond-Roger de Foix in 1208 by Pedro II of Aragon. In this lonely place, the ruins stand out starkly against the usually deep blue sky, buffeted by the relentless winds that gust around this exposed site. Beneath the castle, the Bruyante stream flows ceaselessly around the foot of the castle walls.

On 16th March 1244, many people died at the stake at Montségur. One was Raymond de Belvis, seigneur of Usson, who had arrived at Montségur in the spring of 1243. Among them were Corba de Pereille, the wife of Raimond, and Esclarmonde de Pereille, their daughter. All three had received the consolamentum on 13th March. There was Bertrand Marty,

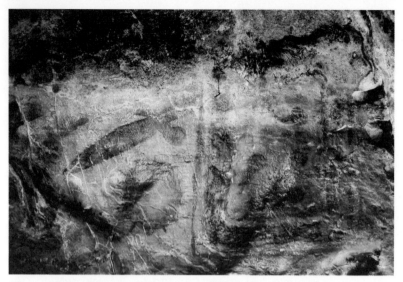

The remains of the inscriptions at Montreal-de-Sos inside the cave, depicting various objects that have been interpreted as "the Grail".

the Cathar bishop of Toulouse and head of the Cathar Church at the time of the siege. He had been at Montségur since 1232. Then there was Guillaume Peyre, a Perfect, a sergeant and agent of Raymond de Pereille. Together with one Clamens, presumably a Cathar Perfect, these two men are said to have transferred the Church treasury into the custody of Pierre-Roger de Mirepoix.

After the capitulation of Montségur, Pierre -Roger de Mirepoix was a free man. He made his way towards Montaillou, then to Usson. Since 1226, the castle had been under control of Bernard d'Alion, who was allied with the French king - although he was married to Esclarmonde de Foix, the Cathar Perfect and modern role model of Montségur.
Did Pierre-Roger "meet up" with something there? Previous analysis of the statement of Raymond Niort also suggests that Usson was the place to where the precious relic was taken.
That Usson forms the key to unlocking the mystery of the Grail is also the opinion of Professor Jean Markale. Pierre-Roger returned empty-handed from Usson. After May 1244 and his presence near Montgaillard near Foix, there is no trace of Pierre-Roger, though it seems that he was still alive in the period 1259-1262. It seems that he disappeared into the veils of history, just like whatever it was that had been moved from Montségur to elsewhere...

Chapter 7
The nature of the Grail

There is a clear relationship between the Grail and the Pyrenees, but what is it? The Pyrenees take their name from the girl called Pyrene of Berryx. Berryx was the last king of the Bebryces, who were themselves the descendants of the famous Taruskes, who founded Tarascon in Provence and, according to tradition, Tarascon in the Ariège. Pyrene is connected with the legend of Hercules in the Pyrenees. It is claimed that his tomb is hidden in "Montréal", the "Royal Mountain", with a stone that fell from the sun. The old accounts add that the royal necropolis is eternally illuminated by this stone. It is said to be only visible to "a handful of very noble warriors". They are divine beings (archangels?), similar or identical to the Knights of the Round Table, initiates who have taken it upon themselves to maintain and safeguard the deposit ever since and for many more centuries to come.

The Greek Hercules is the equivalent of the Egyptian Horus, son of Osiris, Lord of the Underworld. The Greeks identified Osiris with Dionysos. But it is clear that Horus, or Heru in Egyptian, is at the origin of the word "hero" and the "heroic" works of Hercules (Her-cules).
The Sabarthès includes the valley of the Sos, Lordat, Ornolac, all the areas where the caves are situated, Capoulet-Junac and Montréal de Sos, as well as the very picturesque village of Orus. The resonance of this name is very similar to the Egyptian "Horus", and although it is no doubt nothing more than a play of words, it is a striking coincidence when we will soon learn of the many Egyptian artefacts that have been found in this area.

The legend of Hercules says that our hero fell in love with Pyrene, who immediately fell in love with him too. But this love infuriated the young woman's father and she had to run away. She took refuge in an inaccessible place, high up in the mountains, where lots of wild animals lived, somewhere between Gaul and Iberia. It is clear that this setting was the Pyrenees. Hercules hurried after her. However, he was not as quick as the local wildcats. When he found her, Pyrene was lying dead on a rock. All he could do was to cry for her - . and christen the mountains after his lover's name - Pyrenees.
The site of her refuge was therefore high up a mountain in the Pyrenees. Certainly, there are a great number of mountains in this range; indeed many of them are more inaccessible then Montréal, the royal mountain.

69

But it is equally clear that of all the potential candidates, only one mountain can be the correct one, and hence, why not the "royal mountain"?

The region's character is captured in the phrase on its blazon "Sabarthez custos summorum", "Sabarthes, guardian of the top". Underneath are two depictions of the faces of a bear, and underneath that another inscription: "Y anire", "We will go!"
The historians pay scant attention to the bear motif, assuming it identifies the bear of the Pyrenees. But in French, Orus is an anagram of Ours, which means bears. Furthermore, the Roussillon area nearby also uses the bear, the name itself derived from Ursus. Faced with this wealth of bears, it should be pointed out that in the Grail legends, Arthur is also linked with the bear, and in the sky with the Great Bear - the pole stars. "Les Polaires", "The Polar Stars", was the name of a movement to which Otto Rahn belonged. This string of connections might seem all too hastely drawn, but it is clear that as far as symbolism is concerned, they all come within the same jurisdiction.

The story of the "stone of the sun" having come to the region harks back to the stories of the Grail. In popular accounts, the Grail is often identified as the chalice used at the Last Supper, which sometimes doubles up as the chalice which was also used to collect the blood of Christ gushing from his wounds while he was on the Cross. However, another tradition, mentioned in the Grail accounts of Wolfram von Eschenbach, identifies the Grail with a "stone fallen from heaven". Von Eschenbach does not enter into much detail, but other traditions do, and they link it with a stone fallen from the sun... and with the devil, or more specifically, Lucifer.
The story is set in Paradise, where Lucifer tries to tempt Adam and Eve. When God learns that Adam and Eve have acquired certain knowledge from Lucifer, all three are cast out of Paradise. The deposed archangel loses his third frontal eye as punishment for his crime. When this third eye falls on the ground, it solidifies into an enormous emerald. It then disappears from the legends, until it reappears at the time of Jesus, when the cursed stone is apparently cut into 12 by 12, or 144 facets, and placed in the chalice of the Last Supper. At this moment, it is clear that both Grail traditions have become one and the same.
There are, however, variations on this theme. Others argue that the Grail was Lucifer's sword of light as he descended from heaven. As it fell, the "light" grew denser and denser, becoming a stone, an emerald shaped like a cup.
Lucifer, the bringer of light, is popularly associated with the devil or a demon, but originally, he was not. He was God's first assistant, his most

trusted archangel. His "crime" was to give to Mankind certain knowledge that was apparently not reserved for them, i.e. us. This knowledge was symbolised by a tree, an apple tree, depicting the Axis Mundis, the "world tree", which would enable communication between Man and God. The "forbidden fruit", the eating of which would grant Knowledge - and also symbolised temptation - thus became the apple.

The story is obviously important to the Cathar religion, which identified the God of Evil, the Material World, with Lucifer and the expulsion from Heaven. The story of the emerald is also found in the story of Rahn and how Esclarmonde de Foix was its protector.

The Holy Grail within a purely Christian context already has several components: the chalice used at the Last Supper; the container of a beverage; of the first mass; then there was a transubstantiation of the wine into the blood of Christ. Finally, there is the Holy Grail of Joseph of Arimathea, who collected the blood and water running from the wounds of Christ. If we add other traditions to this list, then it is clear that the actual substance and form of the Grail has not been singularly identified.

One magical string that ties several traditions together is the figure of Joseph of Arimathea. Joseph, a wealthy merchant, donated his tomb to Jesus, and was later imprisoned by Caiphas. While in jail, Joseph saw an apparition of Jesus, who told him that during mass, the miracle of the transubstantiation would be recreated. Joseph then escaped from prison, but was quickly captured again and imprisoned for a period of what some sources say was forty years. It is said that he only survived this ordeal as every day the Holy Grail refilled itself.

The Gospel of Nicodemus, written in the 4th century, states that after his release from jail, Joseph went to Egypt, carrying with him an ark made from cedar, which to all intents and purposes seems to be identical to the Ark of the Covenant. This curious gospel also says that Joseph opened the Ark, to have discussions with the "Divine One". This story seems to bring together certain traditions: the Ark, the Grail and other holy relics. But it does not make any more sense of it all; instead, it just seems to collect all the treasures into one place.

Perhaps the absence of a specific identification by Chrétien de Troyes was exactly what he hoped to achieve: endless speculation on its nature. At the same time, Von Eschenbach is somewhat more precise, by claiming it is a stone fallen from heaven. But as none of these items are very specific, and in all events the location of the Grail was never identified properly, it is clear that in the past millennium, hundreds of traditions have sprung up as to what the Grail would be. For Gadal it was one thing, but it is

clear that the Cathars, living at a time when the Grail traditions were put down in writing, must also have pondered whether there was any relevance between their teachings and the new writings that appeared on the scene.

Also, it cannot be denied that the region of the Grail, the area of Toledo and north towards the Pyrenees, is the precise area where the Cathars lived. And not only space conforms, but time as well, for the Grail tradition and the Cathar tradition in the region go hand in hand from roughly 1150-1250, even though the writers of the Grail were situated further North.

There is a long list of material Grails. There was a "Grail" in the abbey of Fécamp, in Normandy, where the hermetically sealed container was said to have originated from Nicodemus, given to him by someone who had apparently helped in the burial of Jesus. The same claims are made in other locations: Bruges, in Belgium, has a container which was returned from Jerusalem during the Crusades and which is said to have contained the blood of Christ. There is Wiengarten in Germany, Valencia and San Juan de la Peña in Spain, Glastonbury in Britain and several other locations in France and Italy.

Some of these traditions are relatively modern inventions, others are not. Some are well-known, others are not. In the latter category is one legend that places the account in the Ariège and the Aude. Furthermore, the account was known at the time of André Glory. In fact, he spoke about it to several people in the region.

The oldest trace of this account can be located in the "Ystoir des Marchs de Peirenes", by the marquis Salans d'Ataran. The text dates back to 1595. However, it seems that in fact this text dates from the beginning of the 17th century, and the document was either antedated, or was a republication of an older document. It was originally written in medieval French, but Lucienne Julien made a careful translation into modern French, which we use as our source.

There is mention of an established militia that has existed for a long time, located in a specifically selected place, and adapted from its original purpose. The site was strengthened and maintained with the single aim of guarding, at no matter what the cost, the place which was not strategic, but highly sacred. Various geographic names are mentioned. Specifically, there are references to "Mont-ségur" and "Mont-réal". The account also mentions a "Sacred Vessel" that was removed from the heavens and returned to Mankind, as soon as the heroes were chosen that would protect the sacred relic. The first of these guardians was named Perilles -

similar to "Raymond de Pereilhe", the man in charge of Montségur at the time of the Cathar arrival in the castle. Then the name of Tytoureil (Titurel) is remembered, as if he was the one who established the cult. There were many volunteers who would join this valiant group. The elected officials were normally retained from the ancient knighthood and they held an unconditional surveillance of the venerated deposit. In exchange, the Holy Vessel would protect them from any battles fought in its name in the following ways:

- If they had been near the vessel, they were immortal that day until the sun set.
- During the following eight days, they could not be mortally wounded.
- Beyond that, unless the vessel had been seen again, the knight could alas be killed during combat. But if he was killed, he was assured that he would be freed from all of his terrestrial faults, and had the certainty that he would acquire eternal bliss.

The vessel was said to be "light" and "clear" in darkness. Its guardians, in its presence, were not subject to "time" and their state of suspension lasted as long as they were within sight of the sacred object. The object itself was invisible to the eyes of the non-believers. The guardians of this Grail were known as "Templeisen". Although they might be called Templars, they could also be called Cathars. The idea that the "sins" of the Earthly existence would be forgiven by knowing the Grail is very similar, if not identical, to the Cathar beliefs.

What remains now is the enigma of the dualistic approach, and whether the Grail served God... or Lucifer. This is where we can hark back to the research of Otto Rahn. Rahn shared Roché's view that the Cathars were custodians of a dualist tradition, but argued that this tradition pre-dated Christianity. He saw their origins in the Celts and the Iberians. His second book, Luzifers Hofgesind (Lucifer's Court, 1937), argues that the Cathars were disciples of Lucifer, the Bringer of Light. At the same time, the Cathars were there to redeem the sins of Lucifer and bring Mankind back to the God of Good. This is an important allegation, which would at the very least justify the Crusade against the Cathars by the Catholics. Whether the Catholic Church was "Judaic" or not - which was the pet obsession of the Nazis - arguing that the Cathars were worshippers of Lucifer would be reason enough for many to go against them. But although it should be made clear that the Cathar Perfects would have agreed that they were evil - as were all the rest of us - the only difference was that they had accepted they were "evil" and wanted to make amends and change the world for the better.

Within such a framework, the question needs to be asked whether the Grail was material, or spiritual - knowledge that had fallen from Heaven? Perhaps it was this knowledge that was passed around and inspired those

who lived in it, to live eternally. In this regard, the message of the Cathar Perfects and the message of the Grail might be identical. And perhaps this explains how stories of a "sacred relic", such as the true teachings of Christ on the soul, as written down in the books of the Cathars, might have been transformed by Chrétien and other writers into the story of the Grail.

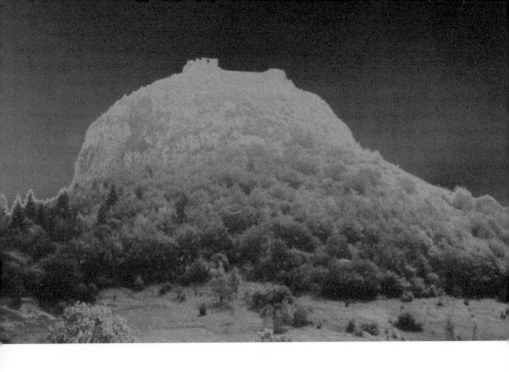

Part 3

Followers of the Grail

Chapter 8
Egyptian discoveries in the Pyrenees

"There were several men who carried heavy speleogical equipment along the path that disappeared into strewn rubble and thorny bushes, emerging from a rough shrubland. Progress was slow, painful and soon it would be overpowered by the summer heat, or the insidious autumn rain. There was yet another solid mass of rock to circumvent, then another, a steep side to climb, a calcareous cliff which rose in front... The heavy bags weighed heavier and heavier, and the breath became shorter and shorter as the hours advanced... a last rocky detour, and finally their eyes were able to locate the openings that other people would find impossible to distinguish here. Maybe they had finally found the entrance they had feverishly sought for many months since."

The above is not a quote from an Egyptologist in search of a forgotten ruin, or of any other form of discovery. This is the story of men progressing through the Pyrenean landscape, in the area of Tarascon in the Ariège. These were men who were following a route said to have been walked by their predecessors, who also left behind certain clues as to how to reach an extraordinary site: a site in the Pyrenees that sheltered ancient Egyptian relics.

After their arduous journey, they reached a cave which they hoped would be their final destination. Progress inside was slow. But these were experienced speleologists and they were accustomed to this type of exploration, searching in delicate underground areas where a step, a gesture or any other movement would irremediably erase traces that might have been intact there for thousands of years. These men worked carefully, each of them being fascinated by history and archaeology.

Suddenly, signs appeared: engravings, clumsy drawings, etc. They were inside a mineral network that only specialised lighting enabled them to reach safely. Still, what they discovered testified to the fact that before them, Man had repeatedly walked through this area, thousands of years ago. Their ancestors had come here in search of many diverse needs, for shelter, out of curiosity, in search of religious sanctuaries... With smoky torches, without any references or modern material, they had walked these caves, often laden with the remains of the dead person whom they hoped to inter within the body of the Earth, to return the dead symbolically to the womb.

Finally, André Glory, in the beam of his acetylene light, located some

engravings: "a bearded stag, a dog that raises his tail, a stag wood, ten horns. Oh! A cartouche with hieroglyphic signs!" The group was awestruck; Egyptian cartouches do not belong in the Pyrenees; they belong on the other side of the Mediterranean Sea, in Egypt. Yet here, in the depths of the cave, are several finely schematised animals drawn under some engravings. Glory stared in amazement at this writing, trying to make sense of them - even though he knew he will not be able to do so. Although he was one of the most experienced and respected speleologists, who would later do research in the famous Lascaux caves, he knew little or nothing of Egyptian hieroglyphs. He could not identify the signs, but later, experts would label the writing as "incomprehensible", an obscure mixture of primitive Egyptian and Phoenician writing.

Shortly afterwards, the team left the cave and walked along the cornice on the cliffside; it was here that André Glory found another cavity, in the shape of a cupola and whitish in colour. Inside this natural rotunda, Antonin Gadal discovered a strange Egyptian ancient statuette. It measured 15.3 cm in height and was a kind of terracotta mummy, enamelled with a dark green face, unrecognizable as regards which deity or person it represented, yet depicted with the traditional cap of the Pharaohs. On the front, from the neck to the feet, a series of hieroglyphs can clearly be distinguished.

Gadal had discovered the statuette behind a well-cut stone, which had attrached his attention because of the unusual signs that had been engraved on the top of this flagstone, which had been used as the lid for the small hiding place.

Glory wrote how "his old friend shouted from behind him; on the left

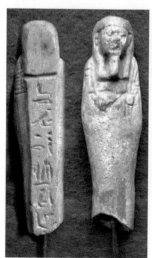

side, he had found an Egyptian statuette in the dirt. A few moments later, with hands that tremble with excitement, a small terracotta statuette, full of hieroglyphs, can be identified. It is a miniature Egyptian mummy, its face terribly mutilated. I stand motionless, astonished, surrendering to a multitude of ideas that cross my tormented soul. How could such a statuette find its way to Ussat? Who had transported it here and why had it been hidden in this stone rotunda?"

Example of an ushabti, a statue of a "helper" in the Afterlife

We are in the early 1940s. The statuette was initially appraised by Mr. Bernoulli, Conservator of the Museum of Zurich, who dated the object to the Ramses Dynasty, in 1200 BC. A second expert examination, this time performed by the University of Montpellier, dated the figurine to be much older, identifying it as an "Ushebti", intended to be used in old funeral rites. The type of clay and the type of enamelling would have originated from the mouth of the river Nile. Although it explains the origins of the statue, it does nothing to clear up the mystery. If anything, it deepens it.

The location was only a few kilometres from the "Superior Churches" of Ussat, as Gadal would refer to the caves which, he felt, sheltered the Cathars. It is an impressive and imposing location and it is easily understood why it would inspire respect, fear and devotion. It is clear that here is a site that has a ritual purpose and specifically a funerary purpose. The site had several entry points, but it is dangerous to venture into, even more so if one is not experienced or adequately equipped. The galleries are extensive and form a formidable maze. It seems that Man has come here from the beginnings of time, but did it mean that the ancient Egyptians came here also? The jump is a big one, too big to make at the moment.

Several discoveries would occur on this site, as more and more explorations and researches took place. The discoveries would range from simple funerary pits to tombs, bones, etc. There would be many objects that showed exceptional craftsmanship, made in bone, jet, lignite, flint, bronze and iron. It is at the bottom of one of these galleries that they found a wall that is covered with writing that resembles ancient Arabic. There is no officially available relief of these inscriptions; although Roché had a piece of the relief on tracing paper; it appears to have been the only one that was made.

At the foot of this wall, a skeleton is resting on its back, its face turned towards the East, adorned with jewels dating from the Neolithic era. The find is remarkable, but even more remarkable is a question that the experts never asked: how was it that our ancient forefathers, after having traversed a complex underground network, twisting and turning, could locate the East without the aide of a compass? Perhaps the other discoveries were so astonishing, that no-one thought to ask that question.

The "other discoveries" were evidence of embalming, including one extremely meticulous example of the technique, which had traces of conservation of the internal organs near the body. In the depths of these caves, deep in the Pyrenees, someone was practicing the ancient Egyptian

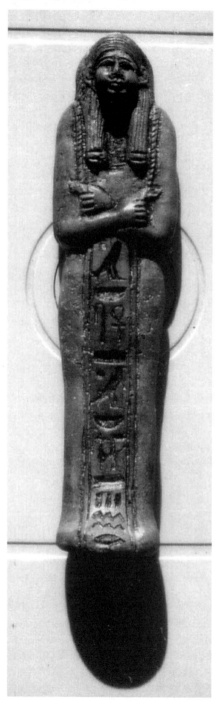

The Egyptian statue found by Glory

funerary rituals. How? Why? Who?

For the moment, let us add that there is no further reference to this skeleton, which makes one think that it is still inside the cave. In an even deeper room, Glory and Gadal found a whole series of thread-like representations of female deities, in an Eastern style. Some are without a mouth, but all have hands with five fingers, which is a rare characteristic of these types of drawings. For Breuil, a celebrated expert on the subject, they are curious symbolic representations of the "Great Mother Deity". Although this is possible, we need to note that the "Mother Goddess" is normally depicted in these areas as a very heavy woman, with pronounced bottom and breasts, symbols of fertility. Whoever made these drawings seems to have followed a different tradition.

As to the cave, we should note that its exact location was somehow "lost" after the initial wave of research. It suggests that the discoverers and the experts did not want to turn the discovery into a tourist attraction. Perhaps it was too difficult or dangerous to reach, but even then, there is always a body of experts who could safely be given access to the site.

As the latter also did not happen, it suggests that the entire enterprise was carefully designed to maintain the seclusion and sacred aspect of the cave. For some, this "absence of detailed evidence" might suggest that the entire episode did not occur. We should note that the presence of Glory in this enterprise makes such a conclusion absurd. Glory and his scientific credentials are beyond any possible reproach; if he was silent on the matter of the location, then all we need to see in this, is a scientist who wanted to preserve a site "as is". Such an approach today is considered to be "good science".

It is impossible not to mention the strange events that followed the discovery of an Egyptian drawing now known as the "Yellow Mother" inside another cave. Admittedly, the worship of the "Mother Goddess" brings to the forefront the myths of Isis, or the Black Madonnas, whose worship started in caves and evolved from there to remain a cult that would continue in grottos and crypts. The colours yellow and ochre were related to the sun - both are the colours the sun assumes, with red being linked particularly with sunset, the sun's death. The same applied in ancient Egypt, where the rebirth and the Afterlife occurred immediately following the red.
Professor Béguoin was informed of this discovery by Doctor Cugullière. Béguoin was probably the first to make a statement on the matter. It was Glory who, after arduous research, had rediscovered the entrance to this forgotten cave. Two metres from the ground, thirty metres inside the cave, he saw a drawing, made out of yellow lines. A figure, about 50 cm tall, was a clear representation of a woman. To quote André Glory once again: "Suddenly, my beam of light meets the sinous lines of a very pale yellow gold. My eyes were glued to it eagerly. It was a goddess, but a new goddess whom I did not know. The half-metre high figurine is however not whole. In certain places, her features are so obscure that what remains are only small chromatic islands which I detected with a magnifying glass."
"A stylised head, thread-like arms, a swollen belly [...] Two large concentric circles are placed at the foot of the body and seem to indicate the characteristics of maternity." For Glory, these symbols represent the two ends of human life: she is the divinity of the living, but also of the dead, and hence is the mistress of the ultimate initiation, the beginning and the end, the alfa and the omega. She reigns in the sky as well as in the darkness of the nourishing earth, she fertilizes and destroys, she governs death and birth. With her arms extended, as she appears on this wall, she portrays happiness. But just as life and death are opposites and need each other, so do the forces of good need the powers of destruction. Reading this description, we can but wonder whether or not these are

81

the characteristics of the Egyptian goddess Isis, one of those deities in Egypt that had underground sanctuaries dedicated to her. Isis was the sister of Osiris, the Lord of the Dead, who was also her husband. It was Isis who restored life to the mutilated body of Osiris, in order to conceive Horus, the divine offspring.

Such speculation apart, the placement of this deity is very interesting. Located only thirty metres inside the cave, it is within the sun's reach. The setting sun often touches the painting, lighting it up for a few minutes before the solar rays disappear as the sun sets behind the Lornat mountains - but the sun's rays have penetrated the depths of Mother Earth, and have illuminated the image.

It was Glory who compared this event with evidence from the megalithic civilisation that others have found in France. The sun penetrating the depths of darkness was indeed a concept well-known to the megalithic engineers. The most famous example of such a solar display can be found in the Irish sanctuary of Newgrange, where the sun penetrates into the depths of the sanctuary at sunrise on the winter solstice. The shaft of the Newgrange sanctuary was specifically constructed so that the sun would light up the floor and the end wall of the inner sanctuary.

But such solar displays are also known in Egypt - and many other cultures for that matter. Egypt has the well-known example of of the Collosi of Memnon, at the entrance of the Valley of the Dead. When the first rays of the sun struck these statues, a mysterious sound was said to come from them, as if they greeted the sun's return. Other temples, such as those at Karnak, were also aligned to solar and stellar phenomena.

As Egypt is not unique in such displays, it is impossible to identify precisely who created this solar phenomenon in this Pyrenean cave. But the important observation to be made here is that we find such a solar phenomenon in a cave in the Pyrenees, a cave which was obviously a very important religious sanctuary - a funerary complex, the sacredness of which was underlined by the solar phenomenon visible near the entrance.

The dying sun would bring the ancient goddess to light, animating her with a vital clarity, before returning her to the eternal shade and the darkness into which the dead inside were permanently plunged. The "Yellow Goddess" was briefly united with the sun before it died. It showed the cycle of life, but also how death and life could only connect at certain times, in certain places - and how those locations were "passages" from one world to another: the next world.

Several archaeologists (E. Tourquet, F. Chaupt, P. Mauret), scientists

(professors Francet de Bachet, P. Metare) and an eminent Egyptologist (Sebastien Fannet) studied the elements, information and objects and the necropolis itself, including the strange Egyptian statuette that had been found at the very beginning of this Pyrenean discovery. All agreed that the objects were undoubtedly manufactured on the borders of the river Nile, thousands of years ago. They excluded the possibility of a hoax, a joke or anything else. In their expert opinion this was a genuine find. However difficult it might be for some to accept Egyptian findings in the Pyrenees, it is clear that this is the reality we have to face.

The archaeologists should be commended for making such bold assertions on what is an out-of-place find. Rather than try to cover up the discoveries (as others would in later days), they accepted it as a legitimate find. But unfortunately, that was all they did. These specialists were not able to put forth a theory that would explain or would begin to explain the why, who or how of this discovery. It defied all accepted history, as Egyptians or even a strong Egyptian influence was believed to be totally absent from the Pyrenees. The Egyptians had conquered nations, but not this far to the west.

We took it upon ourselves to subject the entire sector in which the discovery was made to a more detailed study. In 1979, we observed that several discoveries of a similar nature had taken place, though these had been more modest in scope: there were various decorations, burials, objects, and diverse remains. We also personally assisted in various speleological explorations, which led to fortuitous discoveries of a similar nature as those made by Glory and Gadal. Still, these did not lead to a rational explanation, even fifty years after Glory's researches.

Today, the hieroglyphic script that was discovered has still not been deciphered. It is not even clearly attached to an indexed language. The same applies to the Egyptian text visible on the statuette, which for some reason seems to defy all interpretations. Mr. Guenin himself, in a letter of 19th November 1943, recognised the importance of this effort vis-à-vis this "enigma that is outside the common scientific run". He consulted nearly forty ancient Eastern alphabets and could only make a partial appraisal of the text, which was "Bastulo-Phoenician", and went back to the 5th century BC.

We know a little more about the small figurine. We know that between 1000 and 3000 BC, someone who was a faithful admirer of Isis deposited the small Egyptian enamelled terracotta figurine. No doubt the deposit occurred as part of a funerary ritual. But it is not a mummy; it is the depiction of a servant, with hands crossed on his chest, carrying a bag of grain on his shoulder. Its use, on the other hand, is very surprising, as we read the explanation rendered by an expert: "Each morning, the god

83

Thoth indicated that a certain number of the "dead" were to work in the Osirian fields of Ialou. In order to escape this order, the deceased would send his double, this terracotta servant, who would answer in his place. He bears an inscription to that effect on his dress, an extract from chapter VI of the Book of the Dead, which in essence reads: 'Oh! Ushabti, if I am invited to carry out all the work, cultivate the fields, fill the channels with water, remove the sand of the East in the Occident, you will answer (from the word ouschab, to respond) me here.'"

The expertise of the figurine was entrusted to Madame Desroches-Noblecourt, pupil of Professor Drioton (National Museum of Louvre) and the text above was translated by Madmoiselle Guentsch-Ogloueff of the Guimet Museum. This expertise excludes any possibility of inaccuracy or other doubtful interpretation. In spite of this undeniable expertise, certain authors still prefer to doubt the authenticity of the object, and assume that Gadal simply falsified it and distorted the discovery, by taking the object himself to the place where it was discovered. Such a Machiavellian plot would seem totally at odds with the character of Gadal, who was known for his honesty and his remarkable integrity. A dreamer he might have been, but the evidence does not suggest that he was a fraud. Still, mud sticks and if an allegation is repeated often enough, it will become established as a fact - and unfortunately, that fate seems to have befallen this statuette.

The figurine was put on display for some time in the Museum of Tarascon in the Ariège. Its present whereabouts are unknown, as it disappeared from the collection. Only certain photographs remain attesting to its existence. However, there is one detail that does attest to the good faith and the extraordinary discovery of Gadal. It is that a second such statuette was found in similar circumstances in the cave of Portel, also in the Ariège. Such ushabtis were rare for the tombs of the 12th Dynasty, the era of Ramses. They were found in greater quantity in the tombs of the Pharaohs of the 18th Dynasty, and onwards, until Ptolemean times, when they disappeared - largely at the same rate that the ancient Egyptian funerary rituals disappeared.

One small detail about the artefact seems to have escaped the attention of these researchers. In Glory's sketch of the "yellow goddess", her belly seems to be presented like an apple cut into two, in the vertical direction. The apple, of course, is a powerful symbol, noted especially for its role in Paradise, with Adam and Eve. Furthermore, we note that Lucifer, the "Bringer of Light", also has the attributes of a solar deity, and could be identified with the sunrays that are "brought" to the statuette at sunset. We note how the Afterlife was often compared with Paradise, the Garden of Eden possibly being identical to a state of the soul that existed before

earthly incarnations began to occur. As a consequence, women will have to give birth to their offspring in this world, in a painful manner. The apple cut into two is a clear indication of the female reproductive organs. Could this be a coincidence, or is it intentional?

It is clear that there was a sun cult in the caves of the Pyrenees, a cult that was linked with a cult of the dead. These two were the chief components of the Cathar faith, and it might have been a main reason why the Cathar mission struck such a powerful cord with the local population. If the Cathar teachings indeed preceded Christianity and formed a type of "original religion", then solar worship linked with worship of the dead are likely components of such a religion. Evidence of this can be found across the world, from Newgrange in Ireland to Egypt and the Book of the Dead with its emphasis on Isis and Osiris and the solar deity Ra during his voyage in the Afterlife. As the solar shaft of Lucifer solidified into a stone, so did the sacred seed of Ra solidify into a stone, known as the benben stone.

Did the ancient Egyptians import their rites into this region in the remotest parts of time and did they survive here, through the period of the Cathars, the inhabitants of Arques and finally Déodat Roché?
Certain researchers, faced with these discoveries, have advanced the possibility that this area had been a "safehaven", immune to the various cataclysms, whether seismic, torrential or otherwise, that befall the Earth. This could explain the various ancient remains that were found in this region and it could account for a rather strange phenomenon, which is that many treasures, whether legendary, real, imaginary or fraudulent, seem to be housed in this general area.

Though possible, it seems unlikely. Some have invoked the presence or influence of the "sea peoples" to argue for an eastern Mediterranean influence on the western Mediterranean. The identity of the "sea peoples", their movements and influence, their material culture, and their beliefs are poorly understood by archaeologists who specialise in the eastern Mediterranean. Thus, trying to argue for a presence in the western Mediterranean is precarious at best.
We are on the border of Spain, and Spain is the region which had a strong Arab presence - the Arabs who for the previous millennium, had been masters of Egypt. Were Arab traders the link between the ancient Egyptian tradition and the medieval resurgence? The fact that Arabic writing has been found in some of these caves suggests that the answer is a straightforward yes.

Still, it is a fact that the region is a strange collection - zoo - of animals. There is the man of Tautavel, on the eastern outskirts of the Pyrenees where they fall away into the Mediterranean Sea. This scientific discovery dates the presence of Man in this region to several hundreds of thousands of years.

We note the presence of lemurs near Tarascon in the Ariège - animals out of place to say the least. There are the Basques; there is the race of the "Cagots", a type of human being, whose anatomical details are very different from the norm, so much so that they were subjected to a whole series of defamatory interdicts, often made by the religious and political leaders of the area.

Were they descendants of a group of people, that originally lived in this area - and survived? It is clear that France as a whole was a location favoured by early man: we have the wonderful drawings in the caves of Lascaux, or across the Spanish border, in those of Altamira. All these cave drawings are tens of thousands of years old. All are genuine discoveries, which have never been woven together in a coherent picture that explains the presence of man in this region from roughly 20,000 BC to 2000 AD - thus leaving Tautavel man outside the scope of our enquiry. Although science may not have tackled this complex puzzle, it is clear that the local people must have been aware of traditions and had to "live with it" on a daily basis.

The mysterious race of the Cagots is not widely known about and were it not for the many documents that exist on the subject, one could believe they are nothing more than a legend, perhaps similar to that of the Yeti or other enigmatic beings in other regions. The Cagots were ill-treated, and there are many documents that reveal how they were banished to live on the outskirts of human society. They were found in the valleys of the Pyrenees, and also in the area around Bordeaux, as well as Brittany. They were labelled the "Accursed Race"; disobedience to their oppression would result in even worse living conditions. They were believed to be lepers, carriers of the plague, as well as other contagious diseases. They were claimed to be sorcerers and up to mischief. But although it would have been a quick and easy thing to do in the Middle Ages, they were never exterminated. More curiously, they were often requested to build, repair or maintain religious and other important buildings. Apart from being excellent masons, they were also famous as carpenters, blacksmiths and other types of skilled workmen.

Equally bizarre is the fact that although they were shunted into isolated places, they were neither serfs nor vassals, and were in fact free. Hence, they were free to leave, but for some reason, it seems they did not want to go anywhere. They preferred to live a life of oppression. They were

told to wear a distinctive sign on their clothes, a goose leg made from yellow or red fabrics.

They were feared, as much as they were reluctant to seek contact. They were followers of the religious services, but were separated from the "true believers" by barriers. Strangely, they were tolerated by the Church and in 1514, Pope Leon X even stated that the isolation imposed on them should be lifted. But that order was never respected or applied by the local authorities.

They had to enter the church via a small low door which only they used. Once inside, they might not go to the holy water used by others; they had a stoup of their own. Nor were they allowed to share in the consecrated bread when it was handed round to the believers of the "pure race". There were certain boundaries, imaginary lines in the nave and in the aisles which they were not allowed to pass. In one or two of the more tolerant of the Pyrenean villages, the blessed bread was offered to the Cagots, the priest standing on one side of the boundary, and giving the pieces of bread on a long wooden fork to each person successively.

Who were they? They were thought to be descendants of the Saracen armies of the 8th century. Some thought they were Jewish, others thought they were Gypsies or Moors and some even thought they were the last survivors of the Cathars. Perhaps they were indeed descendants of the Saracens, or from the Arian Goths who were permitted to live in certain places in Guienne and Languedoc, after their defeat by King Clovis, on condition that they abjured their heresy, and kept themselves separate from all other men forever. The principal reason alleged in support of this supposition of their Gothic descent, is the specious one of etymological derivation: Chiens Gots, Cans Gets, Cagots, the equivalent to Dogs of Goths.

But none of these would make it a genuine reason for such exclusion. All of the above were well-known and well integrated within society. The Cagots were "something else". But what? Elizabeth Gaskell confirms the enigma: "All distinct traces of their origin are lost. Even at the close of that period which we call the Middle Ages, this was a problem which no one could solve; and as the traces, which even then were faint and uncertain, have vanished away one by one, it is a complete mystery at the present day. Why they were accursed in the first instance, why isolated from their kind, no one knows. From the earliest accounts of their state that are yet remaining to us, it seems that the names which they gave each other were ignored by the population they lived amongst, who spoke of them as Crestiaa, or Cagots, just as we speak of animals by their generic names."

The word "leper" comes from the Greek word "lépra" and "lépis", which means "scale", as in the skin of a snake. Leprosy is a skin disease and we can only wonder whether the Cagots had a skin that was somehow similar to that of a leper - scaled. This might explain why the Cagots were easily identified. Throughout history, skin conditions have always resulted in prejudice, particularly claims of uncleanness or carrying of disease.

But this is not the case. Various doctors administered various tests, from body inspections to blood analysis, only to find nothing extra-ordinary or remarkable - they were normal. The families existing in the south and west of France, who are reputed to be of Cagot descent to this day, are, like their ancestors, tall, fair and ruddy in complexion, with gray-blue eyes, in which some observers see a pensive heaviness of look. Their lips are thick, but well-formed. They lived to be an old age, but time and time again, nothing physically set them genuinely apart - except human opinion.

With no physical marks, we have to wonder what did set them aside. Might the story of their "scaled skin" although not physically true, be a religiously inspired insult? In Eden, Lucifer is identified with the snake, and hence the "Light Bearer" is identified with an animal that has a scaled skin.

Were the Cagots - or had they been - heretics? It might explain some rather over-the-top claims thrown at them like: "Oh! ye Cagots, damned for evermore!" Their very name, "accursed", might have a double meaning: accursed by the local people, but also accursed for another reason, maybe. Marriages outside of the Cagot were looked down upon - though the temptations and the impetuousness of youth was there - and one authority felt that although the Cagots were fine-looking men, hard-working, and good mechanics, they bore in their faces, and showed in their actions, reasons for the detestation in which they were held: their glance, if you met it, was the "jettatura", or "evil-eye". Certainly, we can bring all of this back to very basic human traits of abuse of their fellow men. But where there is smoke, there is sometimes fire...

In medieval times, it was said that the devil would return either like an angel seated in a fiery chariot, or riding on an infernal dragon. Intriguingly, it is the goose's foot which is identified with the devil (as well as a lion's head and hare's tail). All of these "demonic traditions" were better known in Spain, where Jews and Moors were familiar with an entire series of "demons" which their religious authorities had studied and charted. This familiarity with, if not obedience to a "demonic form" of religion, might explain certain things, but in the end, it is clear that

worship of Lucifer is not identical with the worship of the devil. That connection was made in medieval times by Catholics, who, unlike other traditions, saw the world in black and white (even though it was not a dualist religion - or perhaps because it was not), with Christianity white, and everything else black - including the Bringer of Light.

There is no evidence to suggest that the Cagots were worshippers of Lucifer, but as they were a specific group of people, they must have originally had a series of beliefs. What these were, we do not know - and we need to wonder why, as religious belief is often the best preserved item of a social group, specifically those that are oppressed.
Irrespective of what the Cagots might have been, it is clear that they and others lived in an area where solar worship, the duality of the soul, of a God of Good and a God of Evil date back for thousands of years. And although there seems to be no straightforward link between these ancient Egyptians and the Cathars, time and again, we stumble upon evidence that does seem to suggest such a relationship. If nothing else, it is evident in the lives of Roché and Gadal, who were interested in both.

Chapter 9
Following the footsteps of the Grail

Many have looked towards the Cathars and the Albigensian Crusade as if it was an isolated event. It was not. It should be noted that the Cathars survived the sacking of Montségur in 1244 and lived in the area for many more decades. Even if nothing was removed from Montségur to Montréal de Sos, the entire area breathed the same breath.

Here, in the sides of this mountain, is the small cavity with the strange painting that reveals a direct connection with the history of this strange chalice. The small cave is only one of several, including two long, underground networks that to date are known but unexplored by speleologists.

Near the cave containing the famous "Grail fresco", another cave exists which has other strange depictions. There is a large red cross, with, at its centre another cross coloured black, with equal branches, which itself contains an Egyptian ankh cross. This site was not discovered by Glory and hence it was not placed on their index of sites. Here, another ancient Egyptian object was found, as well as shards of pottery and other bronze objects.

All of these "sacred cavities" of Montréal are on the eastern slope, which means that they received the first solar rays as the sun rises. It seems that Egyptians, Celts, Cathars and Templistes all understood the sacred aspect of this mountain slope. Although this is most likely to be the case, there is no historical document attesting to this possibility. The ankh cross, or the Cross of Life, was accompanied by the representation of the goddess Maat, as well as a third depiction, which is likely to be Nut, though confirming her identity is difficult because of the state of the depiction.

Maat represented the balance and harmony of the world. She illustrated the cosmic order and was in control of the solar barque. But Maat was also linked with the food of the Gods, and as such a connection with the Grail as a source of divine nourishment is not absurd. Maat was always placed at the bottom of temples, symbolising the offering to be made in the search for communication with the gods; she is at the same time food and drink. Again, the divine nourishment that establishes communication with the divine world is identical to the characteristics of the Grail.

The cave of Montréal de Sos is a holy place in the eyes of many people and groups. It was considered by Roché and others to be the location of

90

the Grail, as rescued by the Cathars from Montségur. Rather than arguing in favour or against such a conclusion, it is much more important to note that here, in Montréal de Sos, we are once again confronted with a series of caves in which a preponderance of Egyptian relics and imagery was found. This means it can no longer be a coincidence.

Whatever rituals occurred within these caves had a strong, if not original, Egyptian influence. The nature of these beliefs was Egyptian - imported by the ancient Egyptians themselves, or developed by adherents or descendants of the ancient Egyptian religion, trying to survive, or revive the ancient rituals of the Land of the Nile. Rather than argue for the existence of ancient Egyptian expeditions, or refuge settlements of followers of the cult of Aten (as some have done), we would argue that the "missing link" was Arabic. The Pyrenees formed the meeting ground of the westward expansion of Catharism via the northern shores of the Mediterranean Sea and the westward expansion of the Arabs via the southern shores of the Mediterranean. It suggests that the ideas of the Egyptians migrated to the Pyrenees, just like the Egyptian vultures, migrant birds that winter in central Africa and who venture no further north than the Pyrenees and the Ariège.

In the Pyrenees, the ancient Egyptian beliefs mingled with the local traditions, some of which went back tens of thousands of years. The Egyptian artefacts found in these caves are no different from the prehistoric paintings in the caves of Lascaux, except that in Lascaux, the cave was either closed or forgotten thousands of years ago, whereas in Montréal-

The dolmen of Sem

91

de-Sos and elsewhere, the original belief of the sun and the duality of the soul was added to, and worship was "transformed" to incorporate ancient Egyptian concepts, as well as the story of the Grail. Although they were all different traditions, they shared the same core beliefs, and this is what is at the basis of the accumulation of "enigmatic artefacts" in the area.

Tarascon in the Ariège is connected to Olbier by the D8, a departmental road. Driving towards the village of Montréal, shortly before arriving, on the left slope there rises a very beautiful dolmen, in the shape of a polished spindle. It is known as the "Palace of Sem", or the "Palace of Samson". When Michael Hoskin worked on the orientation of dolmen burials in Northern Iberia along both sides of the Pyrenees, he found that the megalithic tombs that are found in the Pyrenees follow the Iberian tradition of facing the sunrise. It suggests that traditions have indeed changed little over the ages.

To the right of this dolmen, on the opposite slope, is the small village which is known as "Orus". Orus was bigger in the past, but the Black Death of the Middle Ages swept through the village, which was located higher up on the slope. After the devastation, it was rebuilt elsewhere, lower down on the slopes of the Pyrenean mountains. The French pronunciation of Orus is the same as Horus, the divine child of Isis and Osiris. The village sits within two areas: the slope of Montréal that receives the first rays of the sun, and the cave of Tarascon in the Ariège where the Yellow Goddess receives the last rays of the sun. Is this coincidence, or is it design? Is it a "coincidence" that Orus is an anagram for Ours, the French word for Bear? The bear, as in the Great Bear, was linked with the stellar symbolism of King Arthur - and hence we return to the Grail legend. The concept of the Grail linked with the bear is visible in the heraldic blazon of the Sabarthéz: a winged Grail chalice, carried by two bears!
It is a mixture of "things" which at first seem to have no clear lineage, but I would argue that if you see it as a mixture of all traditions that had solar worship and a specific cult of the dead, which incorporated the duality of the soul, then the area begins to make sense.

The Pyrenees are not unique in this enigmatic mixture. Close to the Spanish coast, on the island of Menorca, a small Egyptian statue of Imhotep has been discovered, inside a megalithic complex. Imhotep was the man responsible for the construction for the first pyramid, that of Zoser at Saqqara. Later, he became identified with the god of healing. The statue carries the inscription, in hieroglyphs, "I am Imhotep the god of medicine".

The statue of Imhotep, originally from Egypt, found in a megalithic temple complex at Menorca

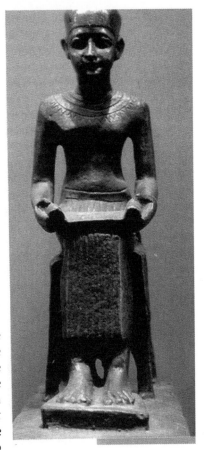

The statue was found in the taula (the Catalan word for table) sanctuary of Torre d'en Gaumes, known to have been occupied from 2000 BC to 123 BC. This typically megalithic monument suggests that at one point the megalithic monuments had connections with an Egyptian cult. How it came to be there, is a question that scientists find "interesting", but which they do not explain.

Archaeo-astronomer Michael Hoskin studied these T-shaped monuments and believed that they were used as places of healing, but that certain complex astronomical knowledge was incorporated into them. He calculated that in 1000 BC, the entrance to the taulas would frame the seasonal rise of a constellation known as Centaurus by the ancient Greeks. In Greek mythology, the Centaur taught medicine to Asclepius, the god of medicine - the Greek version of Imhotep. Hoskin himself suggests an "Egyptian sailor" left the statue of Imhotep.

Indeed, just as the Cathar religion appealed to the people, the Cathar belief, like the cult of the Egyptians, seem to have remained popular, an underground religion, one that thus might have largely escaped the pages of history, unlike the Albigensian Crusade.

Year by year, work within the region continues to strip away every layer of the mystery. But the work is long - and has been long, and is fraught with secrecy, either because it is one researcher's private interest or obsession, or because others believe they are making illegal inroads, and still others hope that whatever is found, would not need to be shared with the rest of us.

As a result, nothing much has happened since the heydays of Gadal, Glory and Roché. Roché himself wrote that "the remains of the past

93

which we have found, allow us to see the area of Ussat and Montségur and Montréal-de-Sos as the centres of the new revelation of the Grail, which we will consequently label the 'Pyrennean Grail'."

This is what the Wanderings of the Grail is all about: it is not the physical removal of a sacred artefact - of which there are too many anyway to find out which one was genuine. The wanderings of the Grail were the wanderings of the Cathar Perfects, who taught the knowledge of the Grail to those who wanted to hear. They had refused material wealth and instead walked from village to village to teach that Man had a soul, that our reality was a falsehood, a creation of the devil, a prison of the mind; that we could escape the cycle of incarnations and return to the "God of Good" if only we could learn... if only we would listen... It is that knowledge that escaped from the walls of Montségur and which continued to be passed onwards throughout the generations, into the time of Roché... and beyond... It is a message for our time, if we could see, and understand what we see in the landscape, and thus make sense of it.

Bibliography

Arques:
- Histoire d'Arques. A. Fabre . Carcassonne . 1885.
- Dossier RLC N°2- Arques ouverture sur un secret.. A. Douzet.

Montségur:
- Montségur et le drame Cathare. A. Moulis. Ed. de l'auteur. 1967.
- Le Château de Montségur. Philippe Sicre. ED. du Paraclet. 1953.

Catharism:
- Etudes manichéennes et Cathares. Déodat Roché .Ed. des Cahiers d'Etudes
Cathare. 1952.
- Le Catharisme. Déodat Roché. Toulouse . 1947.
- Le Catharisme est-il une réligion ? Raoul Lamarque. Ed. des Cahiers
d'Etudes Cathares. 1978
- The Other God. Dualist Religions from Antquity to the Cathar Heresy.
Yuri Stoyanov. Yale University Press, 2000.
- The Yellow Cross. The story of the Last Cathars, 1290-1329. René Weis.
Viking. 2000.

Regional information:
- Chronique d'un village en Sabarthez. Lucile et Rolland Ferrer. Ed. des
auteurs. 1988.
- Montréal de Sos, le Château du Graal. A. Gadal. Ed. R.C D'Or. 1980.
- L'Ariège et ses châteaux Féodaux. Adelin Moulis. Edition de l'auteur.1968.
- Donjon et Castels au pays des Cathares. Coincy -St Palais-Edition de
l'auteur . 1964.
- Sur le Chemin du Saint-Graal. A. Gadal. Rozenkruis-Pers. 1960.

Cagot:
- Histoire des Races Maudites. Francisque-Michel. Elkar.SA. 1847.
- Les Cagots, une race maudite dans le sud de la Gascogne. J-E Cabarrouy
. JD Editions. 1994

Otto Rahn:
- La cour de Lucifer. Otto Rahn. Tchou. Paris. 1974. (Ed Originale 1937)
- La Croisade contre le Graal. Otto Rahn. Stock. 1934.

André Glory:
- Explorations Souterraines. André Glory. Alsatia. 1944.

THE SECRET VAULT
Philip Coppens & André Douzet

Is Notre-Dame-de-Marceille the true centre of the mystery of Rennes-le-Chateau? The authors report on the discovery of a secret vault in that location, which has been at the focus of attention of the main players in the mystery of the nearby village - and its priest, Bérenger Saunière.

*152 Pages. Paperback. Euro 16.90 * GBP 9.99 * USD $ 14.95.*

SAUNIERE'S MODEL AND THE SECRET OF RENNES-LE-CHATEAU
André Douzet

After years of research, André Douzet discovered a model ordered by abbé Bérenger Saunière. Douzet reveals that Saunière spent large amounts of time and money in the city of Lyons... trips he went on in the utmost secrecy. Douzet finally unveils the location indicated on the model, the location of Saunière's secret.

*116 Pages. Paperback. Euro 14,90 * GBP 7.99 * USD $ 12.00.*

THE TEMPLARS' LEGACY IN MONTREAL, THE NEW JERU-SALEM
Francine Bernier

Montréal, Canada. Designed in the 17th Century as the New Jerusalem of the Christian world, the island of Montreal became the new headquarters of a group of mystics that wanted to live as the flawless Primitive Church of Jesus. But why could they not do that in the Old World?

*360 pages. Paperback. GBP 14.99 * USD $21.95 * Euro 25.00.*

From the same publisher

NOSTRADAMUS AND THE
LOST TEMPLAR LEGACY
Rudy Cambier

Nostradamus' Prophecies were *not* written in
ca. 1550 by the French "visionary" Michel de
Nostradame. Instead, they were composed
between 1323 and 1328 by a Cistercian
monk, Yves de Lessines, prior of the Cistercian
abbey of Cambron, on the border between
France and Belgium. They reveal the location
of a Templar treasure.
The language spoken in the verses belongs to the medieval times of
the 14th Century, and the Belgian borders, not the French Provence in
the 16th Century. The location identified in the documents has since
been shown to indeed contain what Yves de Lessines said they would
contain: barrels with gold, silver and documents.

*192 pages. Paperback. USD $ 17,95 * GBP 11,99 * Euro 22.90.*

THE STONE PUZZLE OF
ROSSLYN CHAPEL
Philip Coppens

This book will guide you through the
theories, showing and describing where and
what is being discussed; what is impossible,
what is likely... and what is fact.
The history of the chapel, its relationship to
freemasonry and the family behind the scenes, the Sinclairs, is brought
to life, incorporating new, forgotten and often unknown evidence.
Finally, the story is placed in the equally enigmatic landscape
surrounding the chapel, from Templar commanderies to prehistoric
markings, from an ancient kingly site to the South, to Arthur's Seat
directly north from the Chapel – before its true significance and
meaning is finally unveiled: that the Chapel was a medieval stone
book of esoteric knowledge.

*136 Pages. Paperback. Euro 14,90 * GBP 7.99 * USD $ 12.00.*

From the same publisher